PICTURES FROM THE COUNTRY

PICTURES FROM THE COUNTRY

\diamond

A Guide to Photographing Rural Life and Landscapes

BY RICHARD W. BROWN

Camden House Publishing, Inc.

A division of Telemedia Communications (USA) Inc.

For My Mother and Father

BOMC offers recordings & compact discs, cassettes and records. For information and catalogue write to BOMR, Camp Hill, PA 17012.

Library of Congress Cataloging-in-Publication Data
Brown, Richard W., 1945–
 Pictures from the country : a guide to photographing rural life and landscapes / by Richard W. Brown. — 1st ed.
 p. cm.
 ISBN 0-944475-17-5 (acid-free paper : hardcover) : $29.95
 1. Nature photography. I. Title.
TR721.B76 1991
778.9'3—dc 20 91-13365
 CIP

Edited by Thomas H. Rawls

Designed by Eugenie S. Delaney

Camden House Publishing, Inc.
Ferry Road
Charlotte, Vermont 05445
First Edition

Trade distribution by
Firefly Books Ltd.
250 Sparks Avenue
Willowdale, Ontario
Canada M2H 2S4

Printed by Tien Wah Press
Singapore

Contents

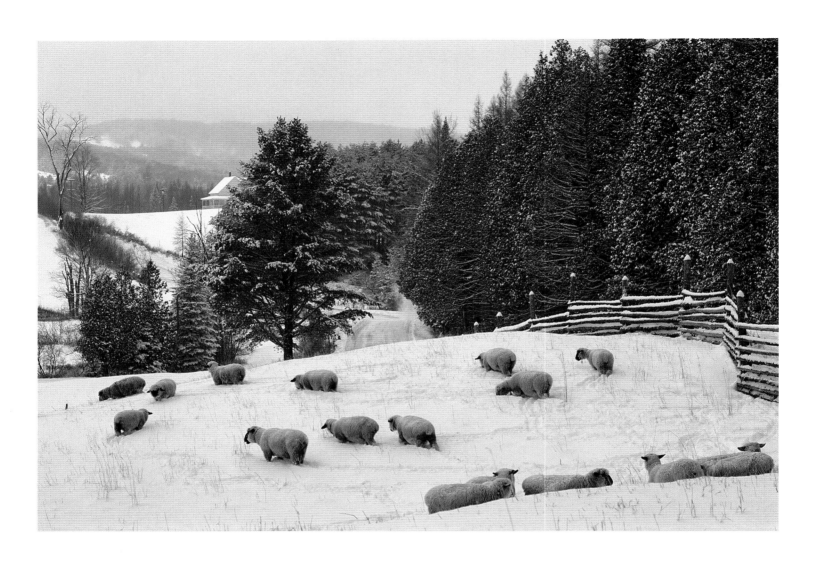

NORTHEAST KINGDOM, VERMONT

An early November snowstorm has forced these sheep to forage in the snow until their owner herds them back to the barn for hay and shelter. This picture contains elements typical of the region that I have photographed for twenty years: mixed forest and fields, a plain wooden farmhouse and winding dirt road, plenty of snow, and perhaps most characteristic, sheep fence cobbled together out of what is readily at hand: old barbed wire and cedar poles cut from the woodlot.

I achieved the elevated perspective of this picture by climbing a nearby knoll and shooting down on the sheep with a 105mm telephoto lens.

Introduction

The beginning of my career as a photographer coincided with my purchase of a small hill farm at the end of a dirt road in the remote northeastern corner of Vermont. Determined to combine a love of photography with a love of this hard-won but beautiful landscape, with its fiercely independent, make-it-do-or-do-without inhabitants, I spent the first few years thoroughly absorbed in photographing my surroundings. This Northeast Kingdom, as it is called, reflects a two-hundred-year evolution of farmland, woodlot, and near-wilderness—a patchwork of fields and pastures bounded by a dark border of fir and hemlock and, on the eastern horizon, the snow-covered spine of New Hampshire's White Mountains.

Here was enough subject matter to last a lifetime. Inspiration was no problem—I was seeing everything for the first time. Wildlife abounded. One June evening, I counted thirteen deer grazing in the hayfield behind my house. I encountered wild creatures I had only seen in pictures—ermine, bobcats, pileated woodpeckers, even a lynx. They were all exotic and wondrous to me, and their presence confirmed that this land had never been fully tamed. As I drove into town one cold December morning, I was astonished by the sight of a snowy owl perched incongruously on the steeple of the Catholic church. After studying the owl's white form for several moments, however, I thought, what more fitting weathervane to forecast the approaching storms of winter than this silent arctic visitor?

I like winter, and I love to photograph snow, and here I was served at least a five-month smorgasbord of relentless two-day blizzards, chronic flurries, blinding whiteouts, storms with large hypnotic flakes softly drifting to the ground like thistledown. At times I felt as though I was living in a life-sized version of the tiny glass-enclosed snow scenes you used to buy at the five-and-dime store, eternally locked in this season, in which each shake of winter's hand would set the snowflakes to drifting and swirling.

Above all, I wanted to photograph the remaining hill farmers and their disappearing way of life. Many of my neighbors farmed in ways little changed from their grandfathers'. It was not uncommon to hear the chatter of a horse-drawn mowing machine on a still summer morning, or to smell freshly turned earth and wet harness as a team of broad-backed roan draft horses leaned into their collars to plow an uphill furrow. Horses built like Volkswagens was how one farmer described them.

Photographers tend to be wanderers, and I am no exception. After several years in which I worked totally and, I might add, blissfully in one place, assignments began to come in, some in far-off and exotic locations. Now I do most of my shooting away from home. But before each trip, I always make time for one last-minute walk up the abandoned road that goes past my house, or I spend a few minutes in the rocking chair on the porch looking at my ragtag flock of sheep grazing in the remains of the apple orchard that borders the front lawn. I want something to take with me, quiet moments before the hectic plunge into city

traffic, airports, and strange destinations.

In fact, when I'm traveling as a photographer, I'm always looking for echoes of home, for other rural places where a similar life is being lived but with a different accent, a different flavor. I enjoy exploring what is French or Japanese or Australian about a landscape, but in those places I continue to photograph the recurrent themes that first attracted me to the isolated northeast corner of Vermont. What catches my eye is the beauty of the natural world, the seasonal activities of men and women making their living from the land, and those rare rural hamlets where a benign relationship between man and his environment is maintained.

This book is a collection of images that explore these timeless themes, and it is a guide to photographing them. It includes photographs that are my enduring favorites, as well as new work that illustrates the points I am trying to make. Overall, this book reflects my personal evolution over twenty years as a photographer of rural life.

Good photographs are always elusive. For every picture included here, hundreds were thrown away. Two decades of photographing these subjects have made me humble as I approach a picture, and experience has clarified what works—for me—and what doesn't. I firmly believe, however, that every photographer has to recognize his own special way of seeing and to use that knowledge to photograph what affects him deeply. These pictures from the country are simply my own effort to see and record what stirs me.

FALLEN LEAVES, VERMONT

Among the pleasures of living in the country is the ready accessibility of photographic subject matter. This, combined with a close awareness of changes in season and weather, leads to photographs like this one. I found these leaves lying on the abandoned road that runs by my house.

The rich colors of this natural collage guaranteed something interesting no matter where the camera was pointed. Still, I searched for a hint of organization, some unifying rhythm that revealed itself in the haphazard carpet of wet leaves. In this particular grouping, the circular movement in the pattern and the elegant line of the diagonal stem and rain-speckled surface of the largest leaf caught my eye. A stronger picture resulted from choosing a spot where the leaves were visually connected with each other by the design.

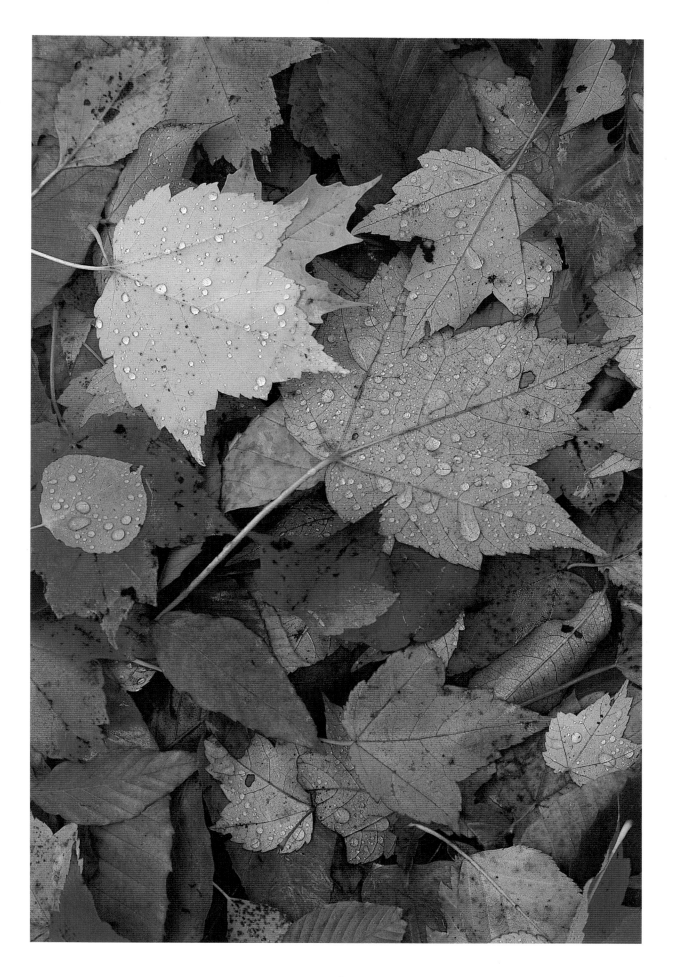

YORKSHIRE LANDSCAPE, ENGLAND

The delicate hazy green of a Yorkshire dale is illuminated by the fading sunlight of a summer afternoon. The composition includes many of the ingredients that lend this part of England its special flavor—the gray stone buildings and walls, the rounded forms of the oaks, and the rolling carpet of grass, softly etched by cow paths.

Water takes the place of sky in this picture by reflecting it and providing a window of pale silver in the expanse of green. Just as important, the water's bright surface draws attention to the figure of the man, his flock of sheep, and if you look closely, his border collie.

To make sure that the shepherd's profile would be clearly silhouetted by the water, I waited until he had followed the sheep to the river's edge before taking the picture. I wanted the photograph to express my admiration for man's benign presence in this landscape, and the shepherd's tiny but well-defined outline held the key.

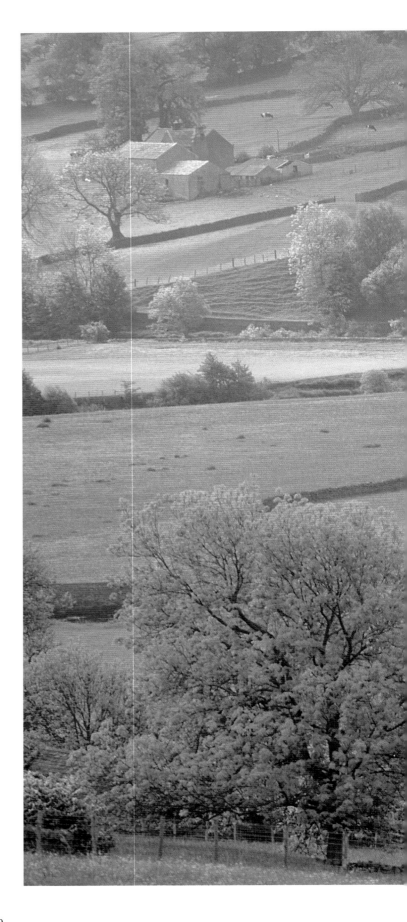

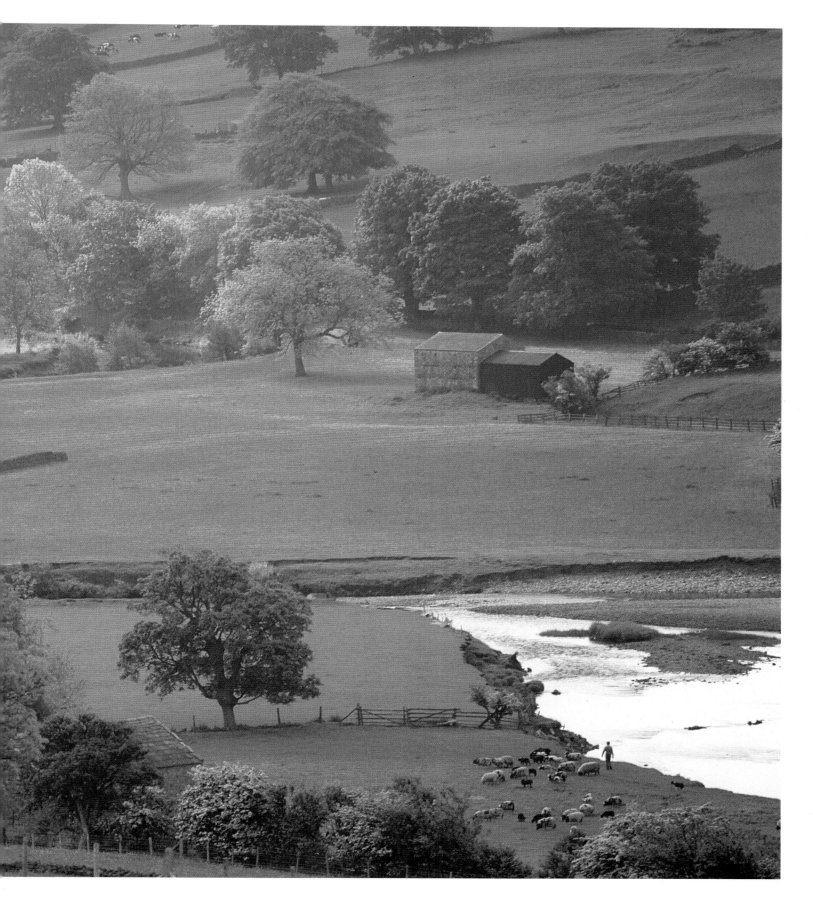

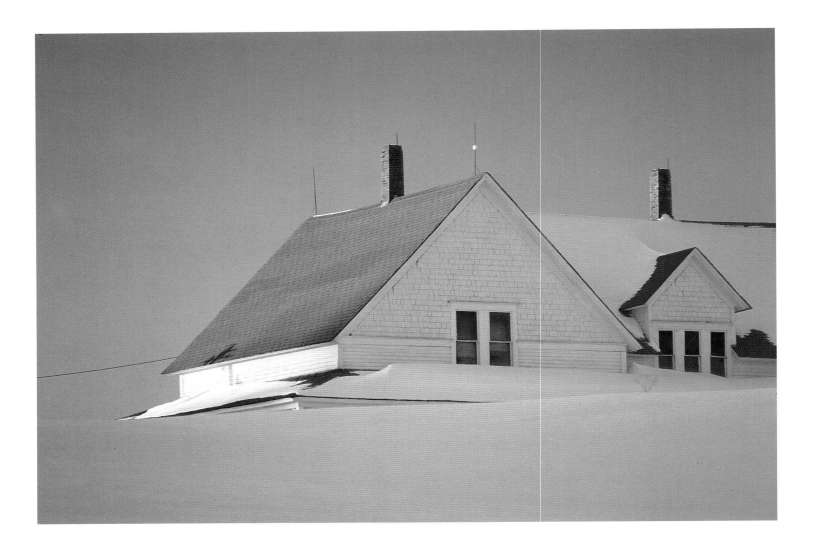

FARMHOUSE AND SNOW, VERMONT

Snow simplifies the landscape, and winter offers more subjects with abstract qualities than any other time of the year. Here I used a 105mm telephoto lens, which allowed me to include in the photograph only the essential shapes of the building and to leave out all surrounding distractions. By positioning my camera and tripod low to the ground, I was able to block out the lower half of the house with the snow-covered hill in the foreground. By choosing this angle, I set the remaining gables and chimneys adrift on a sea of powder–blue snow.

This picture depends on several other elements: the delicate difference in hue between the blue of the snow and the blue of the sky, and the contrast of the warm, sun-struck clapboards and chimneys with the cool azure that surrounds them.

Simplicity

I am a great believer in simplicity in all aspects of life and especially in photography. Simplicity should not be confused with ease of effort, however. Making a clear, simple statement with a camera is rarely easy. Approaching photography with a sensible economy of equipment and a fresh, receptive eye, striving for clean, well-seen images is demanding but rewarding work.

My most successful photographs have been made by simplifying, by paring down what is in the image to what most powerfully conveys the mood or theme I feel. Photographs are made as much by what is left out of the picture as by what is included. Our surroundings present us with an almost chaotic overabundance of visual stimuli. Photography is a means of selecting what we respond to most strongly, of editing and thereby emphasizing. The camera is like a small portable frame that we use to separate the pictures we see from their surroundings.

In my photography, I often search for pictures that hint at some inherent order or rhythm, photographs that stress patterns or shapes that echo one another—the roof gables and chimneys echoing each other in the photograph on the opposite page, for instance. I try to capture this sense of order as simply as possible, primarily by leaving out everything I feel detracts from the essence of the image I want to capture. Framing a harmonious image might require me to use a different lens or to move the camera slightly. This shift might enable me to eliminate a birch tree that disrupts the rhythm of the others, or it might allow me to isolate the triangular shapes of the farmhouse gables in a field of snow.

Unfortunately, simplifying the image is not always as straightforward as it sounds, because often we must force ourselves to leave some of the appealing elements out of a scene. In the photograph of the French farmwife and dog on page 15, for instance, I was faced with too much of a good thing. They were standing in the doorway of an old farmhouse, and its faded wooden shutters and lace-curtained windows were a subject in themselves. At the same time, in the drive, the woman's equally photogenic husband was leaning against his prized ancient Citroen. Finally, rolling French countryside and venerable oaks made up my backdrop. Everything I saw was exciting. But I decided that what I wanted to capture at this moment was the bond between the woman and her dog, so I focused only on them. If I had stepped back for a wider shot, too many elements would have competed in the image. No photograph can do everything at once, and when presented with a wealth of possibilities, you do better to concentrate on one at a time. After taking this picture of the affection between madame and her dog, I photographed the affection between monsieur and his Citroen, followed by the shutters and windows, and finally the countryside beyond.

Naturally, when you are striving for simplicity, it is important to realize that less is more only up to a point, after which it becomes less again. You have to learn when to leave well enough alone. To be effective, photographs can't be distilled to such an extent that they lose all their edge or sense of tension. The image of the farmhouse half hidden by a snowbank

(page 12) would be less interesting if the space to the left of the roof had been eliminated. That space pushes the building toward the right-hand side of the frame, creating a slight imbalance that adds energy to the photograph.

Similarly, in the image of the woman and dog, I included certain homely details—the dish towel put out to dry, the key in the lock, the straw push broom hung ready for sweeping the doorway, the watering can—all to suggest how the tender moment she takes to stroke the dog's head stands in marked contrast to the routine toil of her day-to-day life.

Another way I have tried to achieve simplicity is by paying attention to what is close at hand and familiar. The pictures I value most are those I have taken within a mile or two of my home. Because I know this area so well, I can anticipate where a hard frost may transform a nearby stand of ferns into taut icy curves like waves in a Japanese print, or where the moon will rise, full and dusky orange on a still August evening. We are always looking for the exotic in far-off places when it often can be found under our noses. If you have discovered a spot that has strong possibilities, but there is no chemistry for you at that moment—the light or the weather just isn't right—return to it, not once, but again and again under as many conditions as possible. You might be surprised by what can happen.

In simplifying, perhaps what is most difficult of all for photographers to find is the simplicity of undistracted thought. Good photography *is* concentration. You need to set aside mornings and late afternoons that are free from interruptions and to spend enough time in one place to allow pictures to happen. While some subjects catch you by surprise, and you rush to photograph them, others are realized after long periods of concentration. There are locations I have initially dismissed as uninspiring and hopeless, only to find after several hours of careful looking that they were full of potential, like the nondescript swamp that yielded the photograph of silver-edged cattails on pages 26-27, and the two plain barns in a neighbor's field that formed the composition on pages 22-23. By quieting my mind and opening my eyes, I found rewarding photographs where I had thought there was nothing. Photographers need to let go of preconceived ideas about how things should look. We have to allow the subject to influence our approach, and through observation and patience, try to see what might be there that is unique. Simplicity is peeling away the clutter, both in thinking and seeing, to reach a point where discovery can take place. It is a constant struggle—to subtract, edit, clarify, and in the end, find the center.

MME. LAJOINIE, FRANCE

This picture was shot on assignment for a magazine story about truffle-hunting dogs and their owners in the Périgord region of France. What appears to be a nondescript though charming mongrel is actually the family's major breadwinner. Here it was the simplicity of the gesture—the woman's outstretched hand stroking the dog's head—and the beatific expression on the animal's face that I wanted to capture. A 105mm telephoto lens—my lens of choice for informal portraits—enabled me to concentrate on the arc formed by the dog's body, the woman's left arm, and the hanging cloth, and to exclude all the extraneous surroundings that a shorter lens would have taken in.

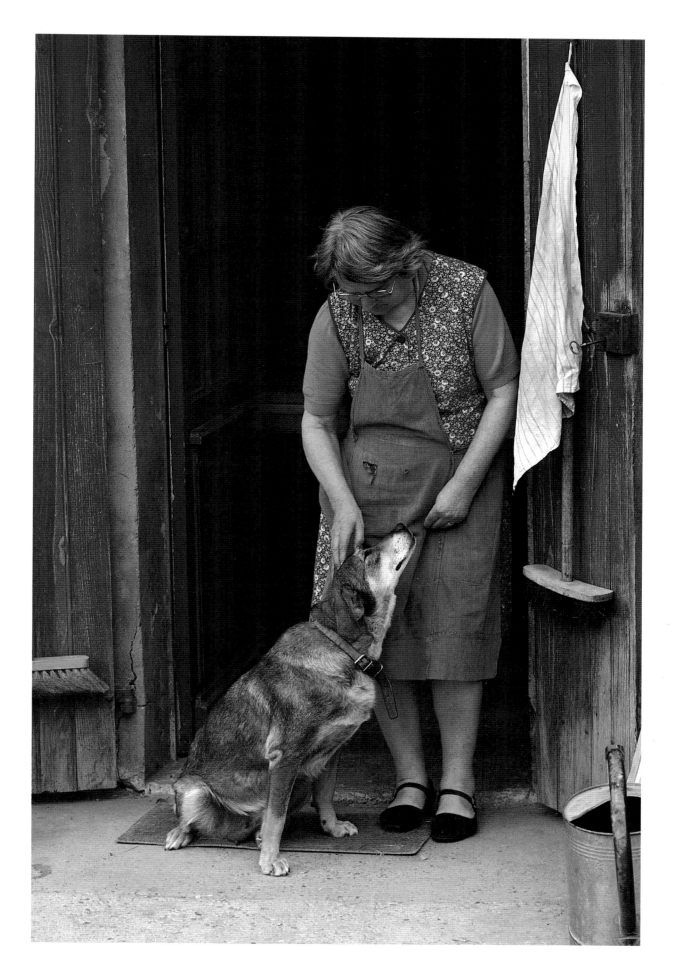

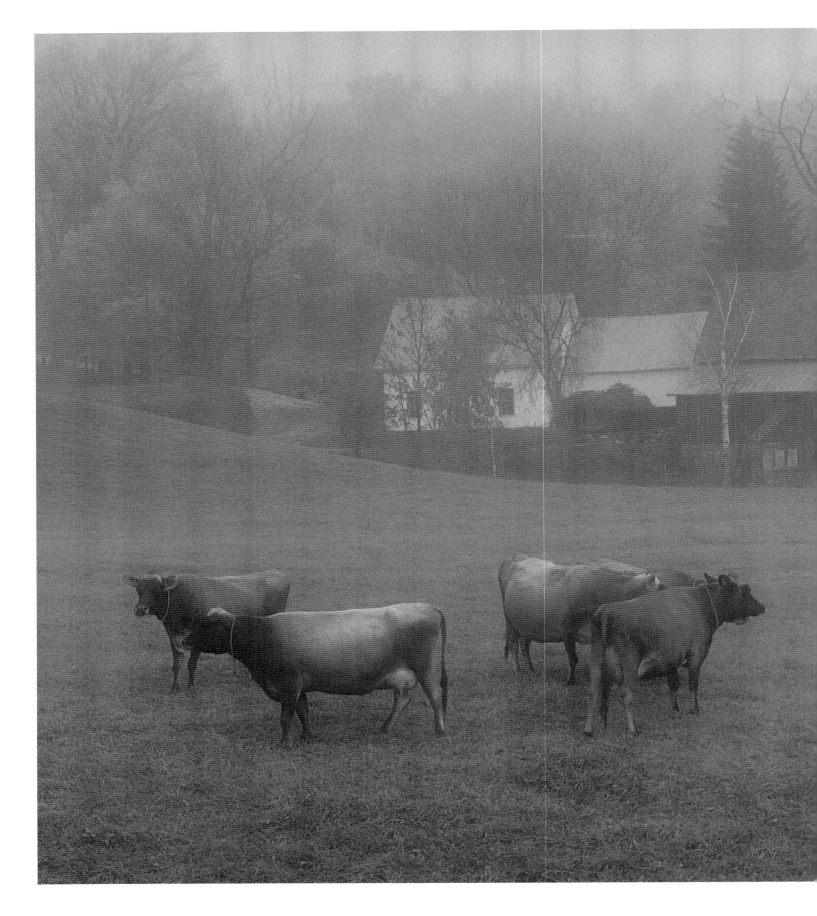

JERSEY COWS, VERMONT

A simple, informal balance exists in this photograph between the Jersey cows to the front and the house and connected barn in the background. Some sense of balance should occur between the elements of any photograph, or it will appear chaotic and meaningless. The difficulty—and the fun—lies in achieving a balance that also allows a hint of tension. Things should look stable but not static—the cows seem to have paused for a moment, but their imminent movement is implied by the way they are pointing in different directions.

There was a peculiar light abroad that morning as I photographed. A combination of dawn, heavy fog, autumn color, and smoke from a nearby forest fire produced an orange-brown haze that I have seen neither before nor since. It had a quality found in paintings by the "Dutch Masters," a quality that I wish I could recreate.

Jerseys are my favorite cows in general, but they shine in the fall when the combination of their Rembrandt-colored forms, turning maples, and weather-darkened barns is irresistible. The baling-twine collars on this small herd give them a certain casual air.

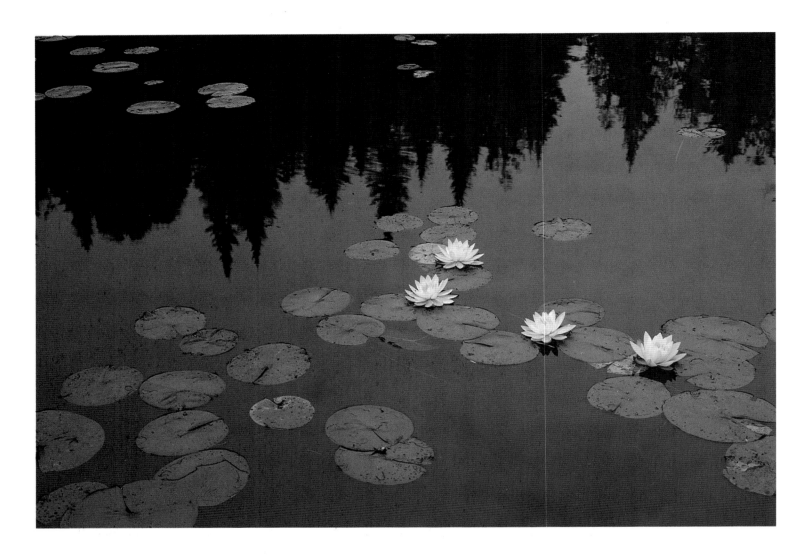

WATER LILIES, VERMONT

MONET'S GARDEN, FRANCE

A pair of hip boots and a 28mm wide-angle lens were used to take the photograph, above, of water lilies and shoreline reflection. I gave up on using a tripod because the water was too deep and the bottom too soft to stand it on. After floundering into position, I had to remain motionless for what seemed an eternity so that the water's surface would calm down and the reflections of the trees would be undisturbed.

The reflection is an important component of this photograph. It reverses the natural order of things, putting the sky at the bottom of the picture and turning the dark row of spruce and fir upside down.

For the close-up study of a single water lily, at right, I used a different, and dryer, approach, shooting from the shore with a tripod. A 200mm telephoto lens closed all the way down to f/32, its smallest f-stop, gave a tightly composed and uniformly sharp image. In this case I used a polarizer to eliminate surface reflections. The water needed to be as black as possible to accentuate the soft pink color and fragile outline of the flower.

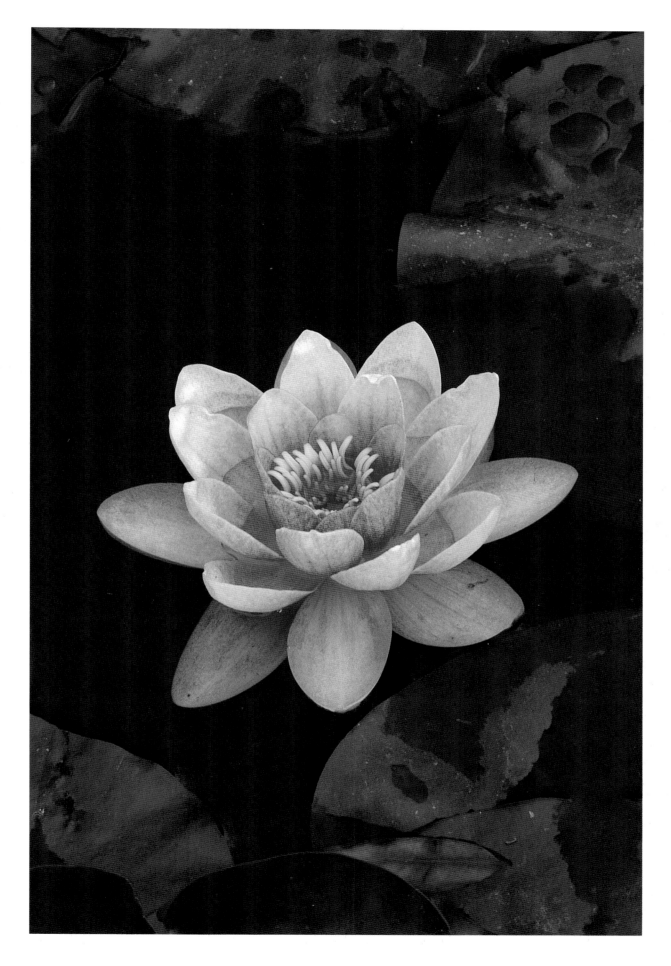

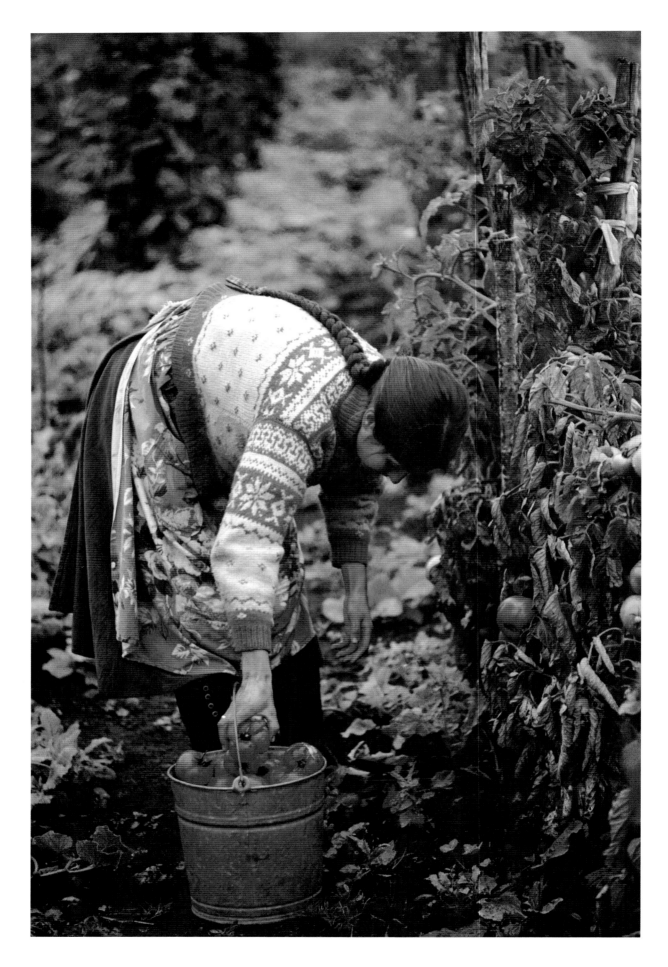

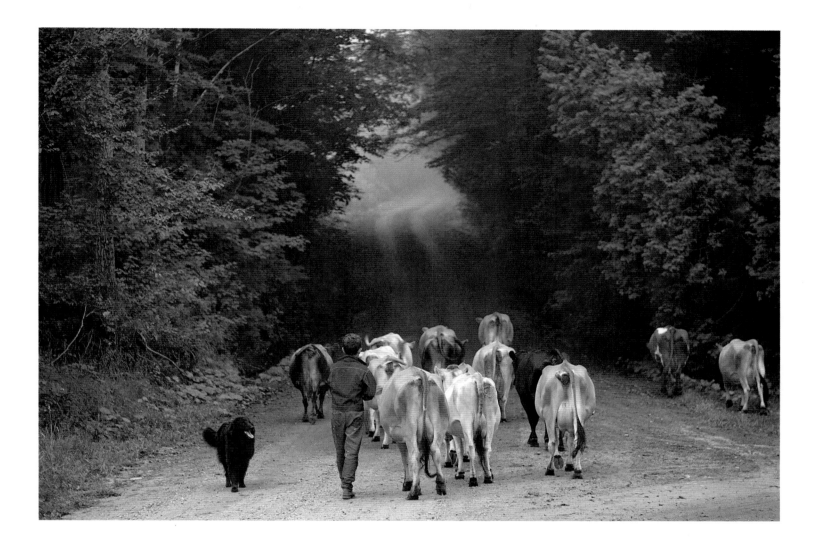

SUSAN'S GARDEN, VERMONT

Focus can be used to simplify, especially when you are photographing people. For this picture I opened my 105mm telephoto lens to its widest aperture, focused on the girl's braid, and let the background jumble of plants merge into a blurred impression of greenery. She stands out clearly because the zone of sharpness is so shallow.

The color red is always a powerful presence. Because of its redness, the single ripe tomato still hanging on the plant succeeds in balancing the figure of the girl and her harvest. That tomato also gives the photograph some momentum. You know it is about to go into the pail with all the others.

PASTURE ROAD, VERMONT

This photograph of a young boy herding some cows to pasture after the morning milking is deceptively simple. Certain chance elements conspired to make it work. First, the fog muted the colors and added atmosphere to the distant bend in the road. Next, the ambling cows happened to group themselves aesthetically as they approached the dark tunnel of overhead branches. Then the dog, with friendly tongue lolling, happened to turn and face the camera. Finally, to bring the whole scene down to earth, the cows' haunches were colored with just the right amount of manure.

This is hand-held, stop-and-go photography done with a 105mm lens. You can't ask the cows to pause, so you walk along behind, freeze for a moment, take a few frames, and then run to catch up.

22

KEMPTON'S BARNS, VERMONT

Scenes don't have to be filled with blazing sunsets or brilliant fall foliage to be of interest. Often subjects that are limited to only a few quiet colors or shades of just one color are more eye-catching. In this case, these worn barns are almost devoid of color. Other than their basic hue of weathered wood, they offer only the barest hint of reddish brown in the rusted roof, brick chimney, and cast-off wagon wheels.

The bold repetitive forms of the two buildings also attracted me. The relationship of the workshed to the large barn with cupola rising behind was the critical element in the composition. By moving to the left or right, closer or farther away, I could bring the buildings together visually in interesting combinations of lines and angles. Changing camera position is as important in controlling the outcome of a photograph as is selecting a lens. In this case, I positioned my camera so that the left-hand roof edges of the two structures formed a dynamic line against the stark white sky, and I included only as much of the barns as was necessary to make a simple, economical image.

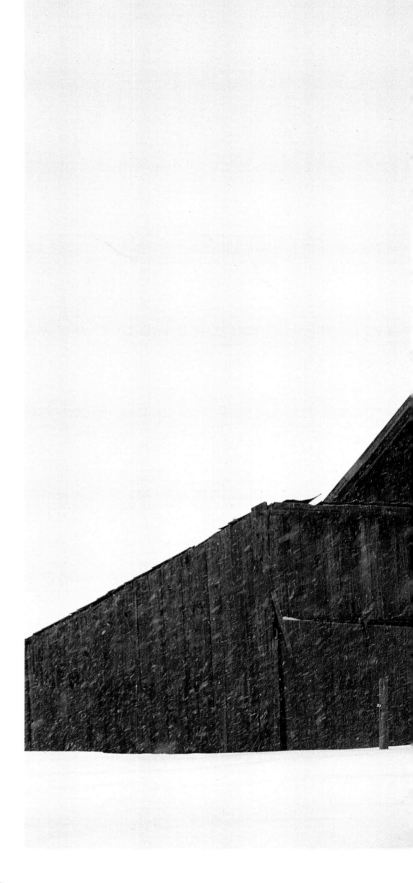

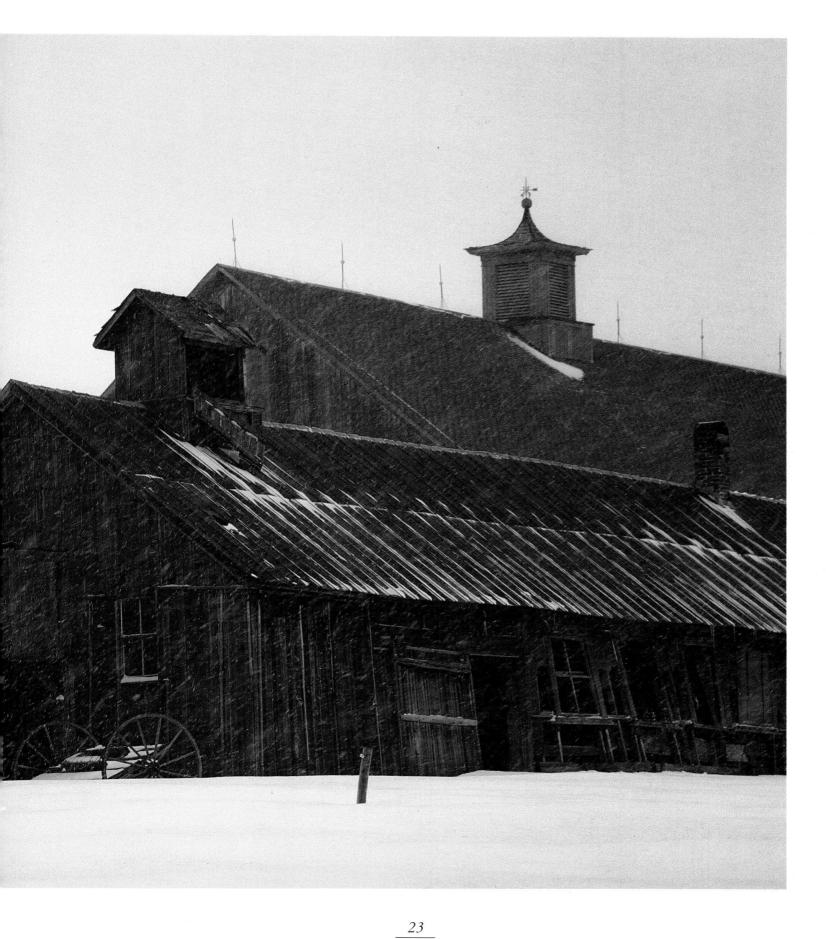

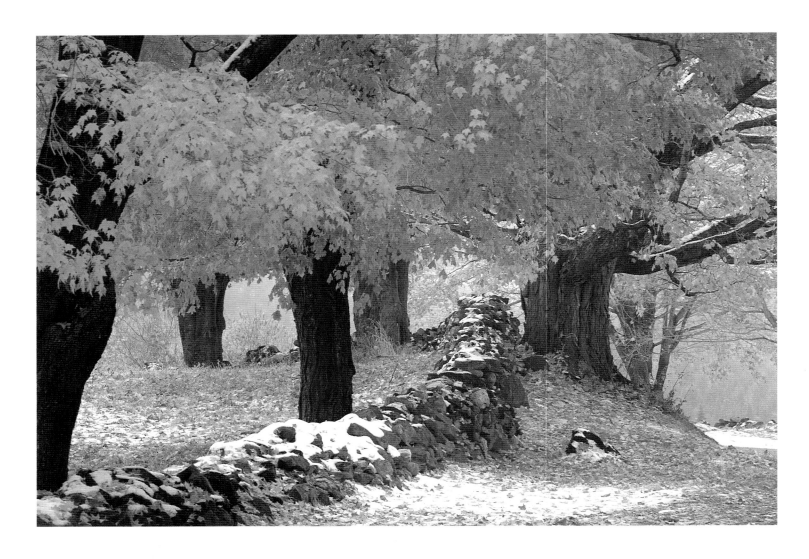

FIRST SNOWFALL, VERMONT

What a difference this dusting of snow makes. Simple occurrences can alter the mood of a scene completely. What might have been a cheerful example of Vermont's celebrated fall color is now tinged with a vague, but not entirely unpleasant, feeling of foreboding. The first cold breath of winter has been felt.

This photograph is really about the passage of time—an ancient frost-heaved wall, century-old maples, and the coming and going of the seasons.

OLD GERRY, VERMONT

Backgrounds always need to be considered when you're taking a photograph. You can't think only about the tree or person or horse that is the subject; you must take into account what is behind it as well. How you integrate or negate the background should be a constant part of your decision-making as you work. Here I wanted to feature the noble, sad profile of this worn-out draft horse, so I waited until he stood in the darkened opening of the barn door before making this portrait.

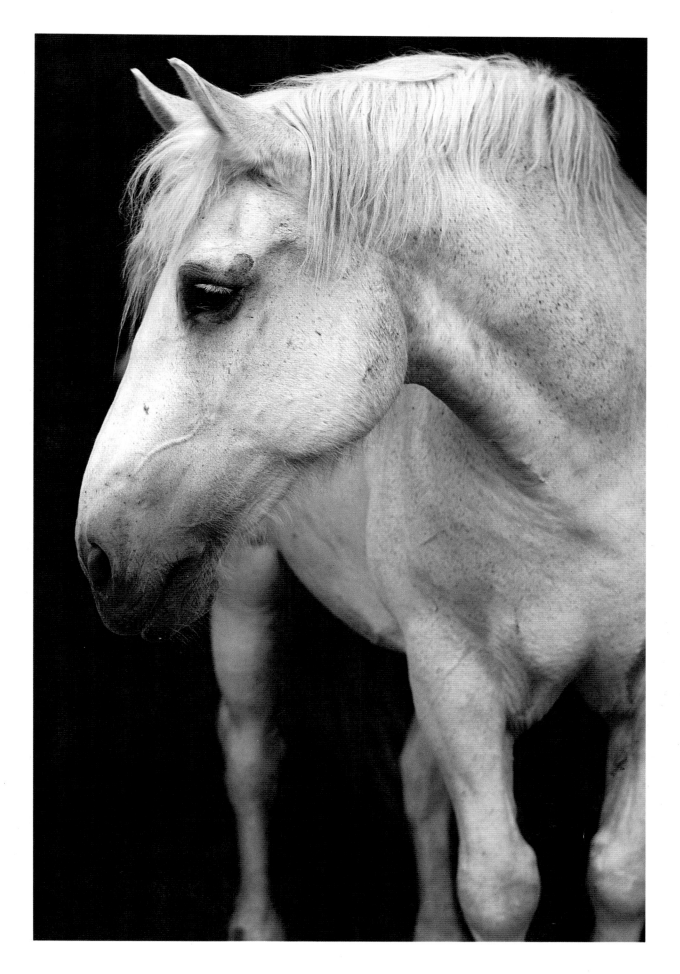

CATTAILS, VERMONT

These cattails grow in a swampy area next to the only paved road that runs through my small town. I must have driven by them nearly every day for years, but as I was usually engrossed in whatever errands I was running, they were invisible to me. Then one morning I caught sight of a muskrat disappearing into the reeds and stopped to investigate. The animal quickly vanished, but I became entranced with the designs and animated patterns of the cattails themselves. I became thoroughly caught up in the excitement of seeing with unpreoccupied eyes.

I have returned with my camera to this ordinary spot many times and have rarely been disappointed. In the spring it is filled with the bright flags of wild yellow iris and the liquid call of red-winged blackbirds, and on July evenings the deep-throated thrum of bullfrogs reverberates among the rushes. Beaver have taken up residence and on several occasions have dammed the culvert that runs beneath the highway, much to the road crew's consternation.

On this particular morning in early November, a hard frost coated the cattails with a layer of rime and the low sun edged each stalk with light. I used a 200mm lens at f/22 to capture as much detail as possible, and I picked a spot where the narrow arching leaves and fat spikes seemed to have the pulse and energy of good jazz. If there is a moral to this brief tale, it is *Don't be blinded by familiarity.* Something worth photographing is literally just around the corner.

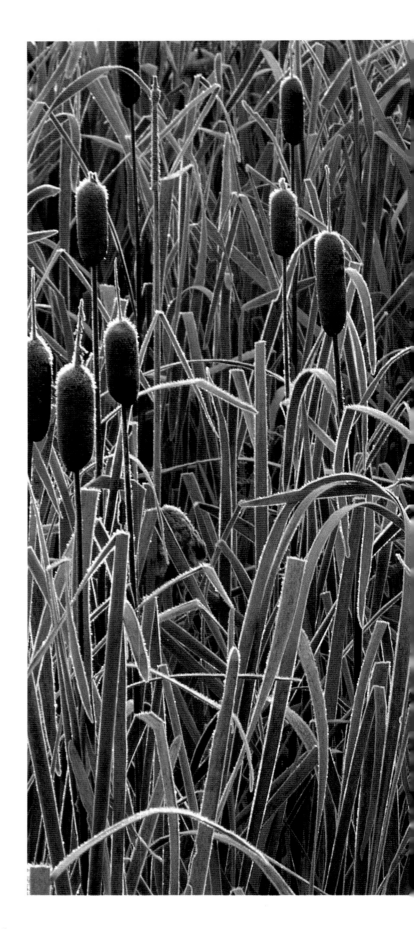

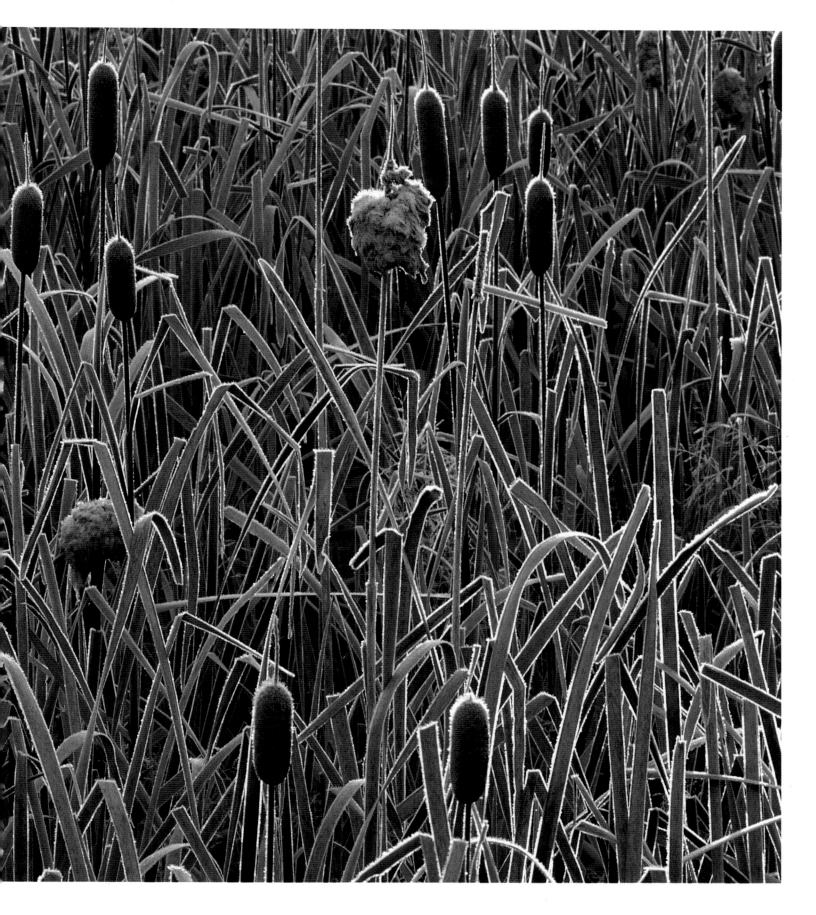

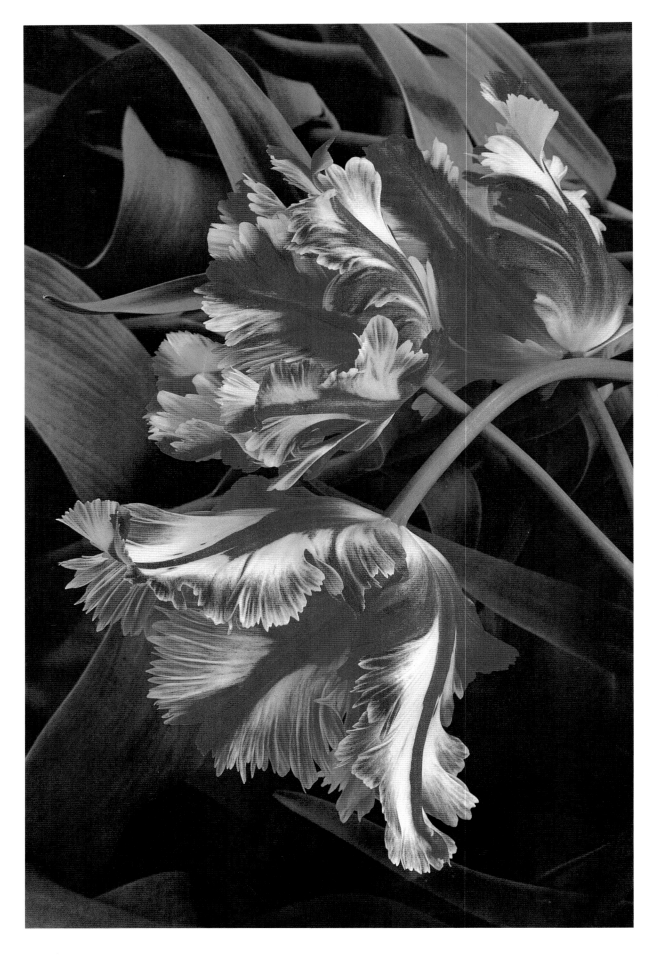

Equipment

You don't need to own the latest technological marvel to get good pictures. Partly out of Yankee stubbornness and partly out of loyalty, I am still using the same Nikon F-2 35mm cameras I purchased nearly twenty years ago. I've watched them mature from shiny new recruits, proudly displaying their Japanese Optical Institute's "Passed" stickers, to battle-scarred veterans. Their finish is worn down to the brass. One shows a deep gash from a fall in the Tetons; another has a large dent from a run-in with an overly curious circus elephant. And I've witnessed the demise of one camera, after total immersion in Minnesota's Boundary Waters. Cameras are like cats: they can take a lot of abuse, but they hate to get dunked.

If the first commandment of photography is "Know thy equipment," I have at least done one thing right. I know these cameras better than I know most of my relatives. I know that the light meter on one overexposes by one half-stop, so I adjust the film-speed setting accordingly, and I know that another balks at cold weather and must be kept warm under my coat between shots. I know that all my cameras dislike inactivity.

While I don't necessarily recommend hanging on to equipment for as long as I have, I strongly believe your gear should be limited to what is truly important. I have seen photographers—I use the word loosely here—so weighed down with cameras and paraphernalia hanging from their bodies that they were practically immobilized.

Over the years, I have pared down my equipment to what will fit into one small carry-on case. It always holds the two Nikons. In my opinion, a second camera body is almost a necessity. It provides a crucial back-up if the first camera begins to act peculiarly— or not at all. In addition, the light meters of the two cameras can be checked against each other for accuracy. A second camera also gives you the option of switching to a different

PARROT TULIPS, HOLLAND

In a Dutch bulb grower's field awash with blooms, these three tulips caught my eye. The graceful arch of stem and splash of vivid color against dark foliage stopped me in mid-stride. I set up my camera and spent several hours trying to do them justice.

Many people have asked how I take pictures like this one. Actually it is simple, but not easy. The impact of this photograph depends on sharpness. I used Kodachrome 25 film; its exceptionally fine grain kept the picture crisp. A tripod and cable release eliminated any danger of camera movement. Because there was a cold wind

gusting off the North Sea, I shielded the tulips with my body and waited for calm intervals before I released the shutter. Using a 105mm lens and a working distance of three feet, I focused precisely on the serrated edges of the petals, with the f-stop set all the way down to f/22.

Of course the hard part, other than being on my knees for two hours, was finding the optimum composition. What I considered most carefully was the margin of darkness around the petals of the lower tulip. I wanted the flower to float in the corner of the frame, but with a feeling that it was pushing against that dark space.

film without waiting until the end of the roll, and finally, it offers a different lens in fast-moving situations that don't allow you to change lenses.

When shooting, I generally carry only three lenses: a 28mm wide-angle, a 55mm standard/macro, and a 105mm telephoto. Occasionally, I will include a 200mm telephoto if I am photographing wildlife or want to concentrate on distant elements in the landscape. I have purposely limited my choice of lenses because I would rather learn the strengths and weaknesses of a few, and what I can do with them in any circumstance, than have to deal with too many choices.

If I were starting out today, however, I might use zoom lenses. Their optical quality has been improved to such a degree and their size has been so reduced, that one or two lenses could serve the purpose of the four I rely on. But because I've come to depend on the particular lenses I mentioned, and because I am in the habit of using them, I tend to see my subjects in their specific focal lengths.

The 28mm wide-angle lens is indispensable for capturing the overall feeling of a scene, its range and breadth. Wide-angle lenses have greater depth of field—the area of sharpness in the picture from foreground to horizon—than long lenses at any given f-stop. Therefore, they don't have to be closed down as much to provide complete definition. They are especially effective in capturing the sense of spaciousness in a landscape and for showing the relationship between people and their surroundings. The photograph of the farmer feeding his cows on pages 34-35 is an example.

A 50- or 55mm lens is considered the standard lens for 35mm photography. The particular one that I use, the 55mm, can focus at very short distances for close-up work, and thus it serves as a macro lens as well. Many photographers feel that because of their unexceptional range of view, 50- or 55mm lenses are apt to yield more prosaic photographs than wide-angles or telephotos. Nonetheless, I use a standard lens often and find it particularly effective in photographing the patterns of nature, like the fallen leaves scattered on top of a pond on pages 40-41. If the subject is sufficiently striking, a special lens may create optical effects that only detract from the subject's inherent beauty.

A modest focal length telephoto lens like the 105mm is an ideal lens for taking portraits and for isolating details in the landscape. It pulls these subjects out of their general setting for closer scrutiny. While our eyes take in a fairly wide angle of view (about halfway between a wide-angle and a standard lens), actually we are constantly scanning our surroundings and then concentrating our vision on smaller elements within this general view. The 105mm is analogous to this concentrated, selective vision. I confess to an inordinate fondness for this lens; it gets more use than any other, and I've literally worn out three of them. When carefully focused and stopped down to f/22, its smallest f-stop, it is capable of capturing images with extraordinary definition.

A longer lens like the 200mm gives results with a much more pronounced telephoto effect. It can pull in distant subjects, making it possible to photograph wildlife from a respectful distance. Lenses of this length or longer compress the feeling of depth in a photograph—a trait used to emphasize the more abstract design qualities in a scene, such as an old fence zigzagging across a hillside, or an undulating ribbon of roadway as it crests and falls over

rolling terrain.

Most 35mm cameras now available have automatic features that will allow you to take successful pictures with little thought given to the fundamental skills of photography. While this technology may seem appealing, freeing photographers to concentrate solely on their vision, the fact remains that the photographer's choices—what should be in focus and which f-stop and shutter speed to use—play a critical role in the creation of any picture. To ensure good photographs, makers of automated cameras have substituted technology for the photographer's judgment. I like to think that many times the photographer might make a better picture than a built-in robot.

If you are serious about your photography, you will avoid cameras that do all the work for you. Be sure that any automated features your camera may have can be easily overridden by manual controls. And don't overlook a whole generation of used, reasonably priced, unautomated Nikon, Canon, Olympus, and other 35mm cameras that are still capable of taking outstanding photographs in the hands of any photographer who has done a little homework.

Whatever your camera of choice, it will only work for you if you are completely comfortable with it. Become familiar enough with your equipment so that it helps you to achieve the picture you want and doesn't stand in your way. Getting comfortable with your camera is like learning to drive a stick-shift car. After enough practice, you begin to concentrate on where you are going, without having to think about how to shift the gears. In the same way, when you watch seasoned photographers in action, it is obvious that they aren't thinking about their equipment. All their concentration is directed toward finding the picture—toward seeing and then capturing the particular moment they are exploring.

One piece of equipment that is absolutely essential for landscape and natural photography is the tripod. A large part of photography's allure for me is its ability to render the natural and manmade world in exquisitely sharp detail. A tripod is crucial to obtaining this precise view because it keeps the camera absolutely motionless during exposure. Shooting early or late in the day, in low light, or at small apertures to ensure adequate depth of field—all these conditions require a slow shutter speed and therefore a tripod. I also find that using a tripod forces concentration and a more disciplined and thoughtful approach than taking casual, hand-held shots. (When using a tripod, I always use a cable release: it trips the shutter without moving the camera, which even the steadiest finger will do.)

Admittedly, there are occasions when speed and mobility take precedence over absolute sharpness, and then a tripod is a hindrance. At these times, you must shoot at $\frac{1}{60}$th of a second or faster to avoid any obvious evidence of camera shake. It is much easier to take sharp hand-held photographs with a standard or wide-angle lens than with a telephoto because the latter magnifies the effect of any movement.

There is a popular misconception that great color photographs are somehow achieved through the magical application of filters. In truth, filters usually complicate matters, creating more problems than they solve. They add another glass surface that has to be kept scrupulously clean. On wide-angle lenses, they can cause darkening at the periphery of the image, and more to the point, they introduce effects that often look contrived, manipulated, or downright fraudulent. If your goal is to communicate your way of seeing as honestly as possible, avoid

all soft-focus, multiple-image, and fog filters, as well as the variable-density filters that darken the sky unconvincingly. If you want to capture the feeling of woods enveloped in fog, do it by finding some real fog, not by manipulating the image with a filter.

There is a difference, however, between what I call "gimmick" filters and those designed to overcome difficult photographic situations. Of the latter, the one I use most often is a polarizer, which helps when the light has flattened colors. It heightens hues, especially on clear days. Its effect is most pronounced in photographs taken with the sunlight striking the subject from the side. (Polarizing can be overdone, however, resulting in lurid greens and overly intense cobalt-blue skies.) Once you have screwed on a polarizing filter, you can control its strength by turning it; you easily judge the adjustment by looking through the lens. The polarizer also helps remove unwanted glare from windows, a disturbing sheen from leaves, or surface reflections from water.

The other filter I use regularly is the 81A. It works well in counteracting the overall blue cast film picks up when you are shooting under a brilliant clear sky, particularly if you are shooting in shadow.

For the sake of a completely clear conscience, I confess to occasionally using a third filter, a faint magenta color-compensating filter, CC05M, which slightly augments the rose hue present at dawn and dusk.

My choice of lenses has been governed in part by the fact that they all take the same size filter. Adapter rings are available, but if every lens required a different diameter filter or combination of filter and adapter, I would abandon filters altogether. Equipment compatibility is critical to me.

Over the years, I've also simplified my choices of film to those that I feel most accurately record my surroundings. Once again, by limiting my choices, I have gained an understanding of each film's capabilities and limitations. Because my work is primarily for reproduction, I shoot slide film. If prints are your primary goal, however, you should consider using color-negative film (although prints can be made from transparencies).

Each brand of film has a distinct personality and palette. It will have its own particular degree of contrast and color saturation and will show a slight bias toward being warm—reddish—or cool—blue. No film records "true" color, and no two people see colors in exactly the same way, so every photographer must experiment and judge which film works best for his or her purposes.

Because sharpness has always been important to me, I use Kodachrome 25—long the standard in color film for fine grain. When more speed is necessary, I switch to Kodachrome 64 or Fujichrome 100. Fujichrome has rich color that is particularly effective on cloudy days. In full sun, however, I find it overpowering.

When evaluating the equipment that you regularly use for photography and when considering the purchase of a new camera or lens, think about whether it will truly simplify your approach to picture-taking. Remember that equipment can only record the picture you see. Curiosity, persistence, passion, and strength of vision, not a glittering array of state-of-the-art hardware, make incisive and memorable photographs.

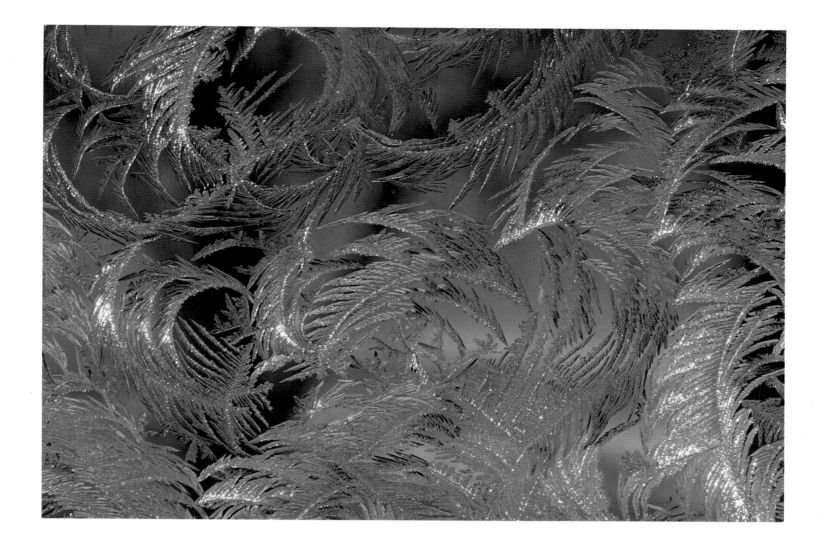

FROST FERNS, VERMONT

This wavelike pattern of frost on a windowpane was taken with a 55mm macro lens. Such lenses allow you to focus at close range. The area photographed here was actually the size of a postage stamp, and the camera was only inches from the glass. When focusing and shooting, I had to breathe softly to avoid melting the frost.

I don't consider this my most original or beautiful image, but it represents the healing power of photography. Six months earlier, I had broken my back in a logging accident. Recovery was slow, and I wondered whether I would ever be able to photograph again. When I realized that I could hobble around the house making pictures of frost patterns, I stopped feeling sorry for myself and began to recover my spirits.

FEEDING CATTLE, VERMONT

I used a 28mm lens to take this photograph of a farmer feeding his Charolais cattle during a heavy snowstorm. The lens's wide angle of view caught the full dimensions of the massive old barn, the activity in the barnyard, and the vastness of white sky raining snow at a steady rate. For me, this lens best conveyed a sense of the rigors of this farmer's daily life. If I had used a telephoto lens instead, I might have revealed more about his features or expression, but the larger view of his connection to the land would have been lost.

In addition to benefiting from the wide-angle effect, this image is strengthened by some fortuitous touches—the subtle demarcation between roof and sky, the spattering of white flakes against the rich red of the barn, the man's form hunched against the cold, and the visual echo of the cow perched on the weathervane overhead.

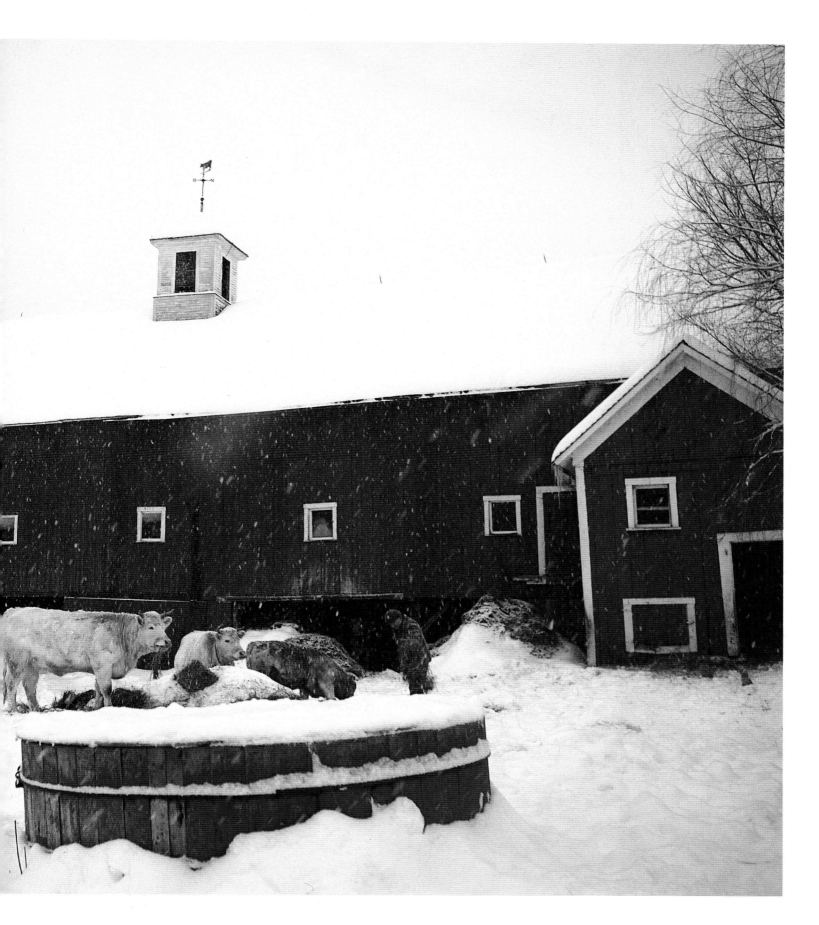

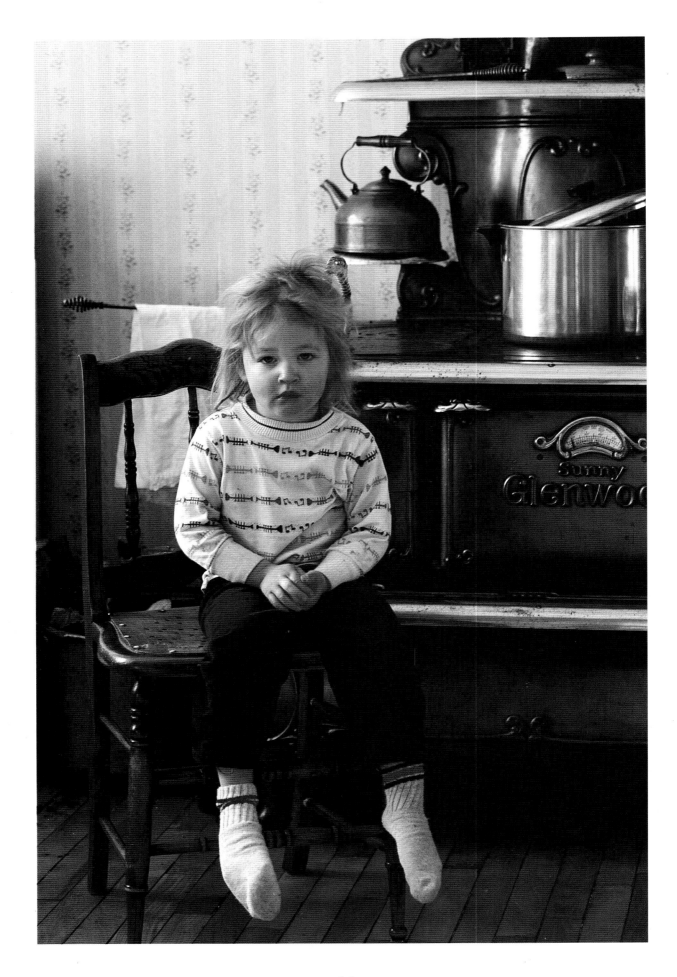

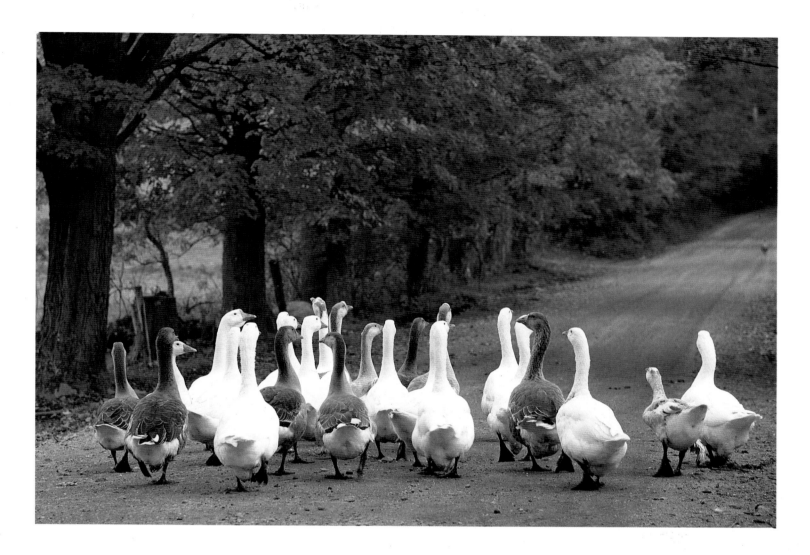

GIRL AND WOODSTOVE, VERMONT

I was visiting a local farm for the first time when this little girl came in from a morning of sledding with her seven brothers and sisters and sat by the wood cookstove to get warm. Her hair was tousled from pulling off her hat, and her fingers were red and stiff from the cold. She had no idea who I was and stared at me intently, more out of curiosity than mistrust. I suspect she had never seen a tripod in her kitchen before.

Not wanting to break the mood, I went silently to work from the other side of the room. Using a 105mm lens and exposures of ⅛th of a second, I shot about half a roll. Her direct gaze never faltered. Either she was a remarkably self-possessed five-year-old, or too frozen to move. What I like best about this photograph are her socks!

TOO MANY TOULOUSE, VERMONT

Being a wanderer by nature and vocation, I have a weakness for photographs with roads in them. They lead you into the picture and hint of something beyond. On this early autumn afternoon I encountered a back-road traffic jam, with one goose trying to pass on the right—and plenty of honking. I stopped the car, slipped a 200mm lens on my Nikon, and joined the fray.

I've always kept a few geese at home, myself. They are colorful, and they're great for keeping unexpected visitors with religious tracts at bay, but you have to watch where you step.

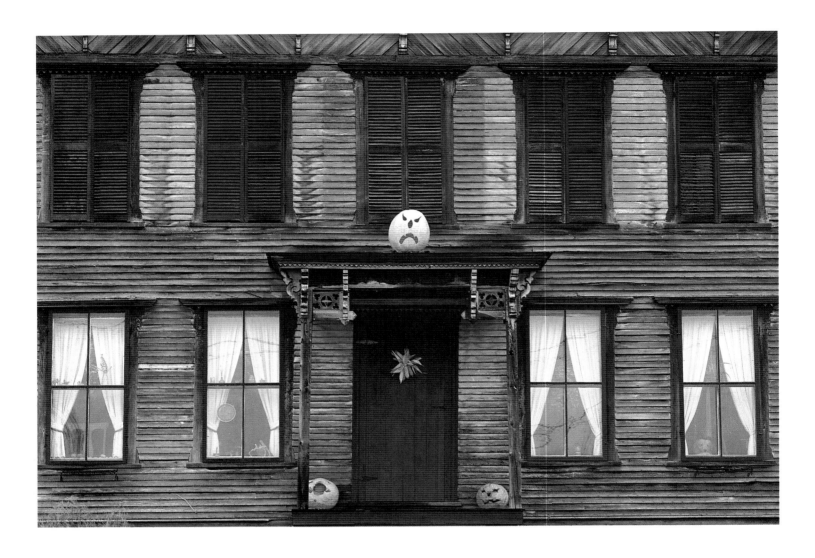

HAUNTED HOUSE, VERMONT

Because I wanted to emphasize the two-dimensional quality of this spooky facade, I used a 200mm telephoto lens to compress the feeling of space. It also let me work well back from the building, where I could shoot it head-on rather than aiming the camera up—and so avoid any distortion of the windows' straight lines.

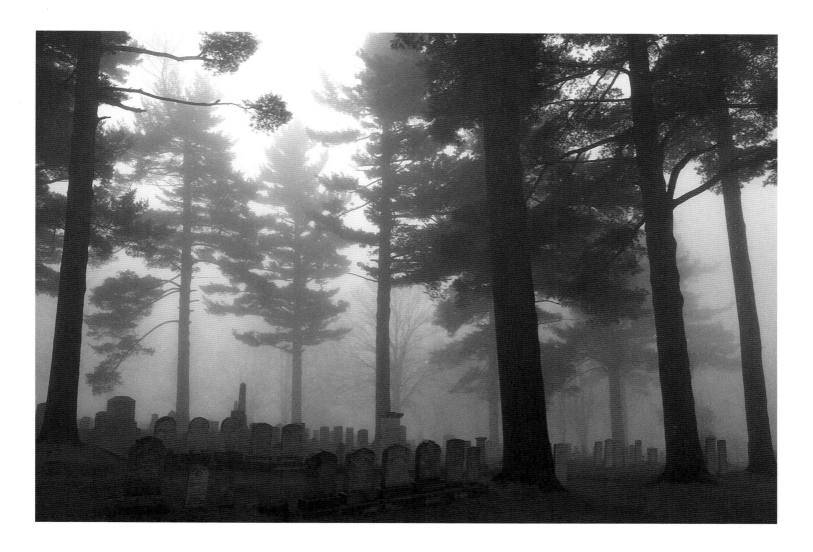

TOMBSTONES, VERMONT

Fog has a tendency to reduce the feeling of depth in a scene, so I chose a 28mm wide-angle lens to counteract this effect and to augment the feeling of height in these towering trees.

Convergence, the inward leaning of the pines as they approach the top of the frame, happens when the camera lens is pointed up at straight objects. This is most pronounced with a wide-angle lens, but in a case like this, where the trees aren't perfectly straight to begin with, the distortion isn't objectionable.

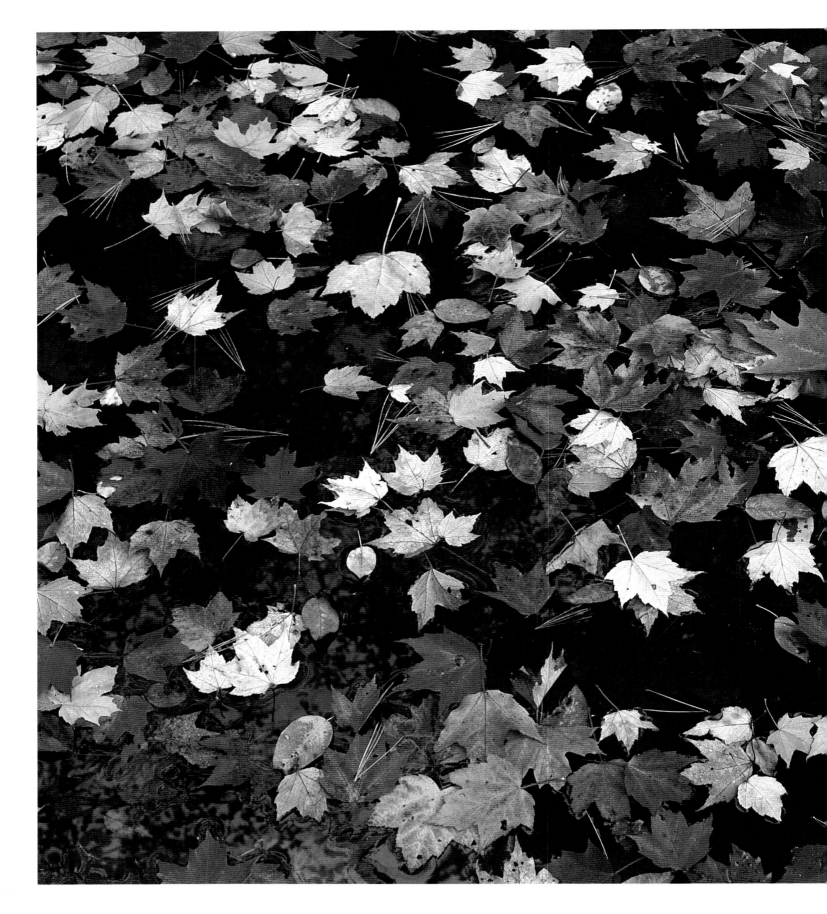

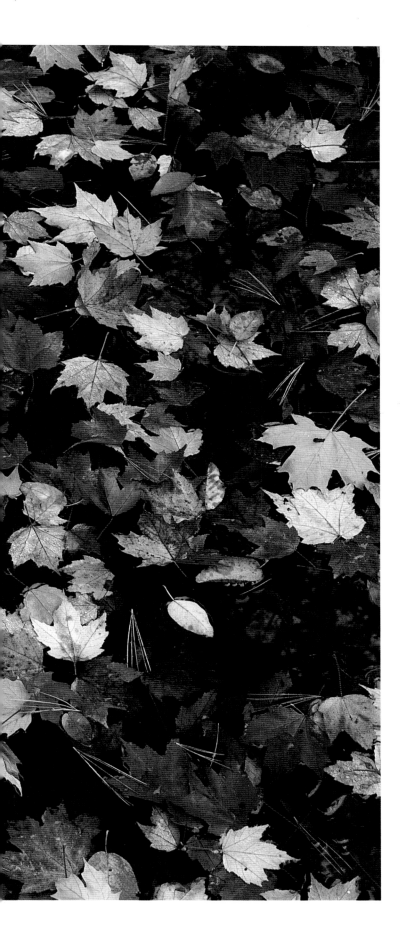

LEAF PATTERN, NEW HAMPSHIRE

Pine needles and maple, birch, and poplar leaves mottle the surface of a quiet pool at the edge of New Hampshire's Swift River. The pale lavender undersides of the leaves resist moisture, so those that have landed face down are dotted with small drops of water.

Although the leaves were stationary, I wanted to convey the sense of motion expressed in their swirling pattern. I came closest to achieving this goal by using a 55mm lens, which took in a yard-wide segment of the pool's surface. A longer telephoto lens would have enlarged a limited selection of leaves, drawing attention to their colors and textures, but because it would have shown only a portion of the pattern, the overall sense of rhythm would have been lost. A wide-angle lens, on the other hand, would have included too many leaves and some of the surrounding rocks as well, which would have detracted from the simplicity I wanted to capture

When taking this photograph I used a polarizing filter; it darkened the water and reduced surface reflections.

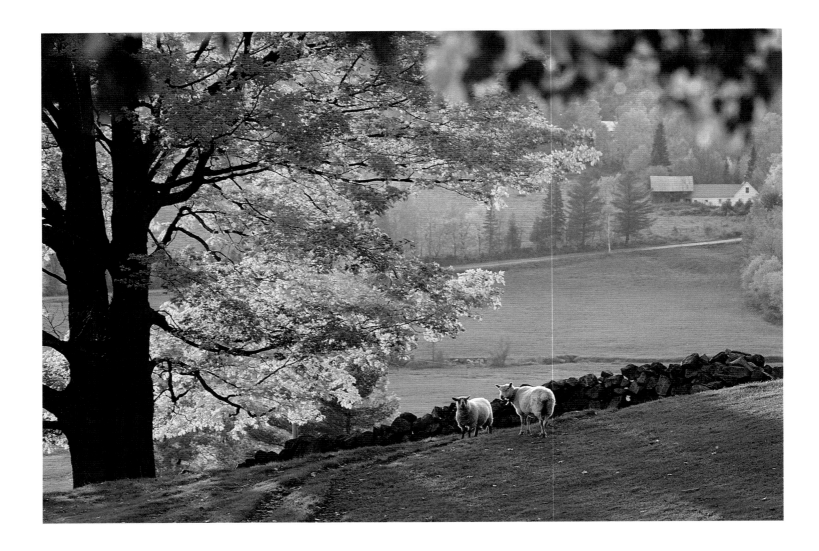

MORRISON'S SHEEP, VERMONT

This backlit photograph of a maple and pair of sheep was taken shortly after sunrise when the warmth and low angle of the light gave a brilliant glow to the orange leaves. For backlight like this you must be sure the light streaming through the tree branches and across the pasture does not strike the lens. Position your camera where it is in shade, or shield the lens with a dark piece of cardboard. Because I wanted to emphasize the light striking the tree and to make the maple dominate the frame, I used a 200mm telephoto lens. Also, I couldn't get any closer to the sheep without frightening them. I included a portion of the orange trees at the right edge of the frame for several reasons: to provide a counterpoint to the large maple, to give the picture a stronger edge, and to contain the subject.

Sheep are infuriatingly timid and about the least intelligent of all God's creatures. My veterinarian once commented, "Richard, a rock is smarter than a sheep." Their first instinct in any situation is to turn and run, even if you are trying to save their lives—or make a flattering portrait. They must be approached with care. What may look like friendly curiosity in the eyes of these two is actually closer to absolute terror; three shots and they were over a low point in the wall and gone. There is often a moment just before flight when an animal will hold perfectly still while it is deciding what to do next. Naturally, sheep take a little longer than most to decide. This is a moment to anticipate and to capture, especially when a slow shutter speed is necessary, as it was here.

Light

Good photography depends on the skillful pursuit of light. The best light is elusive and often fickle; you must stalk it with patience and craft. You learn its habits and idiosyncracies. You rise early and put yourself in places where it might appear and work its magic: transforming an ordinary patch of frost-covered weeds into silver-edged calligraphy, or igniting the branches of an October maple with a saffron glow.

There is nothing I enjoy more than pulling into an all-night diner at 3:30 in the morning for a wake-up cup of coffee just as the faintest light begins to separate land from the eastern sky. Then I'm back on the road, driving past sleeping towns and darkened farmhouses and the occasional lit barn where the morning's milking has already started, heading toward a place where there is the promise of good pictures.

Ideally, I reach my location with time to spare and have the luxury of unhurried concentration to study the emerging landscape. I frame some possible shots, choose the best composition, make sure the f-stop and shutter speed are correctly set and the tripod securely adjusted, and then I savor the moment. But just as often, while I am still driving, some unexpected image catches my eye: a sliver of moon is poised on the horizon above a dark band of trees, or fingers of fog climbing the sides of surrounding hills suddenly flare with a rose-colored light. I slam on the brakes, madly dash with tripod flailing, change lenses on the run, stop, shoot, rewind, and load film, all at a frenetic pace accompanied by a fair amount of colorful language.

These moments last only long enough for a few exposures. Sometimes a low-lying cloud robs me of any opportunity at all. On a clear July morning, the best light is gone by 5:30 A.M., and I won't have good light again until the end of the day. As I am gathering up my equipment, my stomach announces that it is time to get back to that diner for eggs-over-easy, homefries, and sausage. I've often thought that the main reason I'm a photographer is that I get to indulge my weakness for truck-stop cuisine after chasing first light at these ungodly hours.

Dawn light is so sought after because it is warm in tone and produces rich, saturated colors that stand out against the long early shadows. Both sunrise and sunset produce light with more red wavelengths than light has at other times of day. There is, however, a subtle but definite difference between the two. At daybreak, a great deal of moisture is held in the air, and it diffuses light and gives shadows a softer edge. In addition, moisture that has collected overnight at ground level as dew or frost or low-lying pools of mist creates breathtaking possibilities. It may be my imagination, but evening light seems to last longer than the light of early morning. You have more time to look for pictures and to consider a variety of compositions. Shooting always seems to be a little less rushed at this time of day.

Light that occurs during midday—what Ansel Adams referred to as the "bald-headed hours"—is not the stuff of which great photographs are made. As the sun climbs higher,

the light loses its warmth and objects pick up more of the cooler blue wavelengths reflected from the sky. Around noon, the contrast between sunlit areas and shadow is simply too great for color film to handle, and the effect is one of harsh, burned-out highlights and black shadows without detail. Pictures taken at this time of day rarely yield satisfying results.

Overcast skies, however, produce an even, neutral light that is as prized as the light of dawn. Unlike most people, photographers relish cloudy weather. There is nothing like a gray day for photographing the details of nature: a field of dandelions gone to seed, a luna moth clinging to a spruce trunk, or the changing colors of hay-scented ferns in late September.

Cloudy days are also wonderful for photographing people. Skin tones respond with added luminosity to the diffuse light falling from an overcast sky. Distracting shadows that appear under noses and foreheads in sunlight are gone, as are squinting expressions. There is no better light with which to capture the mercurial moods of a child or to document the time-worn figure of an elderly farmer as he stoops to bind a sheaf of corn.

I should stress that there is a marked difference between the light from a cloudy sky and the light in the open shade produced by trees or buildings on a sunny day. Pictures taken in open shade will still be colored by reflected blue light from the sky, which will be more pronounced on film than it is to the naked eye. This blue cast can be countered to some degree by using an 81A filter, which warms the image. At times, however, the effect of reflected blue light can be used to advantage. For example, I have photographed the Monet-like surface of a small pond near my home in the middle of a July afternoon, with better than hoped-for results. When a stray cloud crossed the sun, I was able to capture a cerulean blue light that suffused the lilypads, the lilies themselves, and even the surface of the water, making a far more striking and unique picture than would have been possible in full sun or with overcast skies.

With experience, you begin to recognize when color imbalances are present in the light and how your film will respond to them. For instance, people photographed under a large tree can literally turn green if the light contains enough reflected color from the leaves. On the positive side, there is a delicious indigo color that occurs just before dark on clear, cold winter nights, and incandescent lights produce an inviting orange glow in a farmhouse window on those same winter evenings.

The direction from which light is coming will have a profound effect on how an object appears and how you choose to photograph it. Low, slanting sunlight is the light that most obviously comes from a particular point, and it casts sharply defined shadows, but even diffuse daylight illuminating a room from a window comes from a clearly perceived direction.

Backlight shines from behind the subject, creating a luminous outline, dramatizing and emphasizing contour. The halo of light surrounding the pair of sheep and the branches of an orange maple on page 42 is an example of backlighting. When trying to capture this light, you should keep the camera lens shaded by a nearby object, an adequate lens hood, or carefully by your hand. Otherwise, the resulting flare will spoil the image.

Sidelight spills across the subject from one side or the other, heightening its texture and our perception of how it might feel if we could touch it. The lower the angle of sidelight,

the more pronounced the effect. In the photograph of shells and sand on page 53, the very low angle of the light projected by the setting sun creates a feeling of texture and depth in what is actually a fairly even surface.

Frontlight occurs when the subject is lit from the same direction as the camera. This is the standard lighting that all the beginner manuals have told us to look for—the sun behind our shoulder casting light directly on what is being photographed. Unfortunately, both shadows and the feeling of perspective that they create are minimized by frontlighting, and pictures taken in this light often appear flat and lack presence.

The response of film to all the nuances of light is not always predictable. The mood we envision when we release the shutter may not match the actual result. At times, the light is so ambiguous that we are reduced to guesswork in making exposures. As I have said, light is fickle, and if anything, chance plays more of a role in photography than it does in other creative endeavors. This is why the often maligned but time-honored practice of bracketing should be considered. You bracket by taking a series of shots of the same image at varying exposures. The first exposure is made at what the light meter reads as the correct f-stop and shutter speed. The second is deliberately underexposed by one half-stop; and the third is overexposed by one half-stop. The latter two exposures are insurance against most of the uncertainties that plague photographers whenever there is a chance for a good picture in tricky light. I certainly don't bracket every shot that I make, but in difficult situations I do.

Even if the first exposure turns out to be correct technically, one of the others may be more pleasing aesthetically. A detail of mussel shells on a Maine beach, for instance, might be a more interesting image if shot one half-stop underexposed. The purple outsides of the shells will deepen in tone, contrasting more dramatically with their opalescent mother-of-pearl linings. On the other hand, a study of water and cattails gently backlit by a rising sun might be more effective if done with a slightly overexposed treatment.

These effects are not always predictable, and bracketing can give some pleasant surprises. Equally important are the failed exposures that show what to try next time. You should always remember that the camera's light meter indicates the "correct" exposure by averaging the bright and dark areas in the viewfinder into a middle gray tone. Therefore, picture subjects that are predominantly dark need to be underexposed, and those that are light need to be overexposed to produce appropriate renditions. With experience, you learn that to portray accurately the black space surrounding a person standing in an open doorway you must underexpose; or that brightly lit snow always comes out looking too gray in a photograph unless it is overexposed.

Inevitably, there are times when even an educated guess at the right exposure is difficult. Then I resort to wider bracketing, increasing and decreasing my exposures by as much as two full stops in either direction in half-stop increments until I am sure I have enough insurance. I end up with a series of images that range from hopelessly dark to completely burned out, but somewhere in that range will be the best possible exposure. Like most photographers, I feel a little guilty about bracketing, that it is somehow wasteful. It seems that if I knew what I was doing it wouldn't be necessary. But at those times when light is both lyrical and capricious, when what is important is capturing the mood of one

moment with all the detail and subtlety that the camera and film can attain, a few extra exposures are the least of my worries. I abandon all guilt, take a burst of shots as quickly as cable release and excited fingers will allow, bracket like mad, and then fire off a few more just to be sure.

STEVENSON'S WOODS, VERMONT

Light creates the contrast that gives this photograph interest, picking out the fresh green of the new leaves and throwing the larger maple trunks into shadow. Enough mist was present to make the paths of light and shadow visible in the air itself. Shade from the tree trunk on the left shielded my 105mm lens from the direct glare of the sun.

I took both vertical and horizontal versions of this scene, suspecting that the vertical was the best solution but not wanting to miss any opportunity. This photograph and the one on pages 70-71 were taken within a few steps of one another at different times of the year. I cannot emphasize enough the value of finding areas that have strong personal appeal and returning again and again in all lights, weathers, and seasons to explore and record every change and possibility.

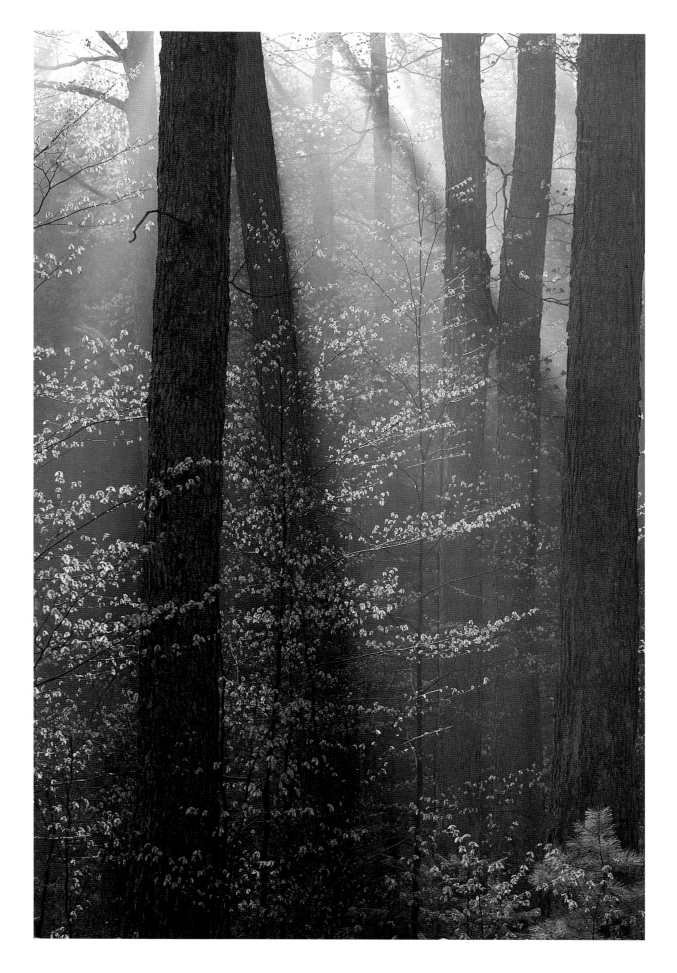

WAITING HORSES, VERMONT

Here is an example of the interaction between the indigo color of a short winter's twilight and the warm glow of the incandescent light inside the barn. I used Kodachrome 64 film, which is color-balanced to record outdoor light accurately, but which renders interior tungsten light with a decidedly amber cast. Photographs taken entirely inside the barn with this film would appear unnaturally orange, but in exterior photographs the small window areas project just the right amount of warmth to create a welcoming mood.

This was a situation that called for bracketing, because there were too many unknowns for me to try and predetermine the correct exposure. For one thing, the light was fading quickly. For another, I knew that my meter was reading this subject as a middle gray, and to give more of a feeling of encroaching darkness, I would need to underexpose the shot. On the other hand, long exposures like this one tend to be underexposed anyway due to film reciprocity—a film's loss of normal sensitivity when making lengthy exposures. So what did I do? I bracketed—a lot.

This picture also represents the value of an if-at-first-you-don't-succeed approach to photography. Several days earlier, I had been photographing this farm, and as it grew dark I finished my roll of film by taking a few throwaway shots of these draft horses waiting to be fed. The results were flawed because the darkness required a slow shutter speed, and the horses, which had moved, were blurred. But the quality of the light—the deep bluish-purple combining with the warm orange glow—was so enticing that I returned to see if I could do better.

The farmer's youngest daughter volunteered to stand behind the barn door with a bucket of grain. Every time she shook the bucket, the horses would prick up their ears and freeze at attention waiting for the door to open, and I would squeeze off a shot or two. In over half the exposures the horses moved, but in this one and several others they remained motionless for a full second. Often it is necessary in such an unpredictable situation to shoot at least a full roll of film to get the hoped-for result. I should mention that the horses were eventually let in, and their patience was rewarded with an extra helping of grain.

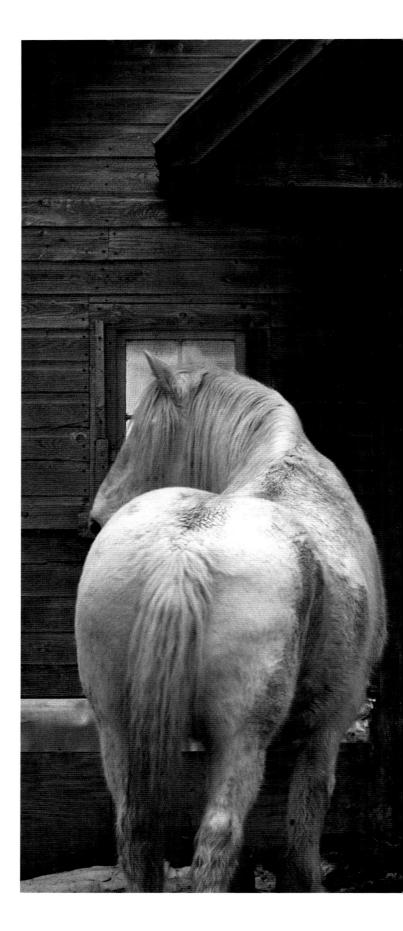

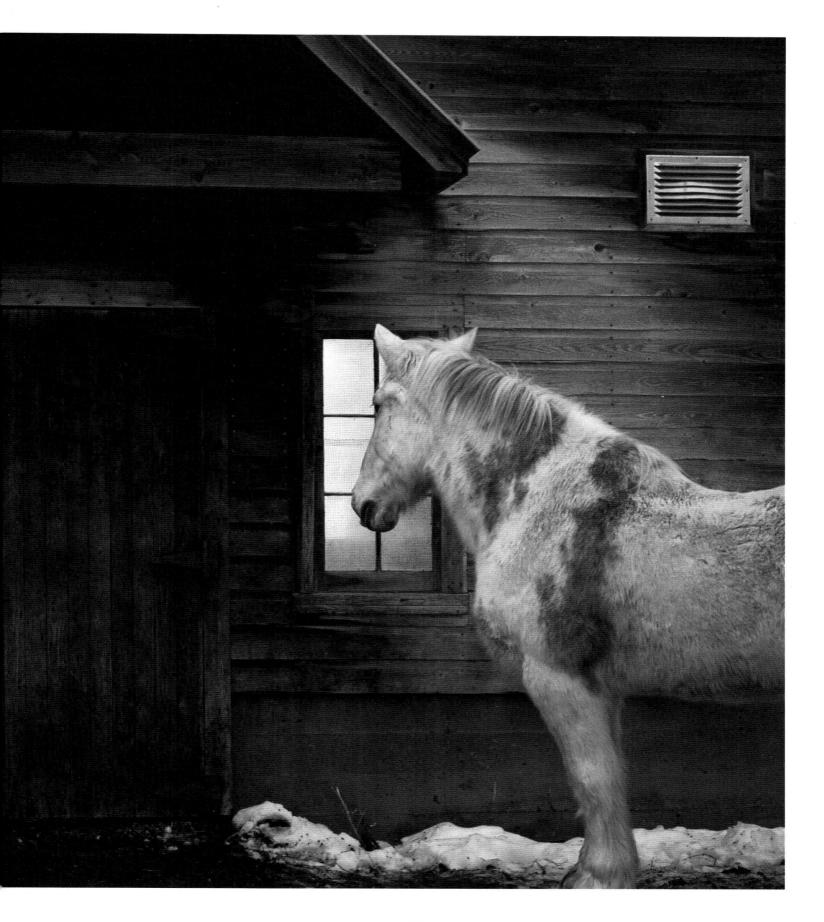

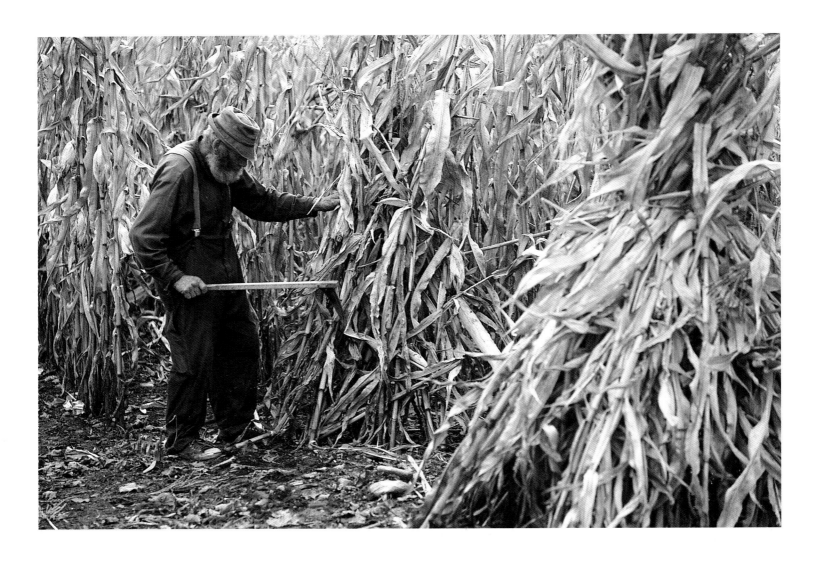

BINDING CORN SHOCKS, VERMONT

A bright overcast sky produces the diffuse, shadowless light in this picture of an elderly farmer gathering corn shocks. The soft, neutral light of a cloudy day brings out the subtle nuances of color and holds both highlights and shadow details within the film's most effective range. This is one of the best lights for photographing people.

I tried to balance the bent figure of the old man with the angular shape of the large corn shock on the right. The limited palette—the russet colors of the withered corn and the earth tones of the man's simple clothing—emphasize that this is November; the year is drawing to an end, as is this vanishing way of life.

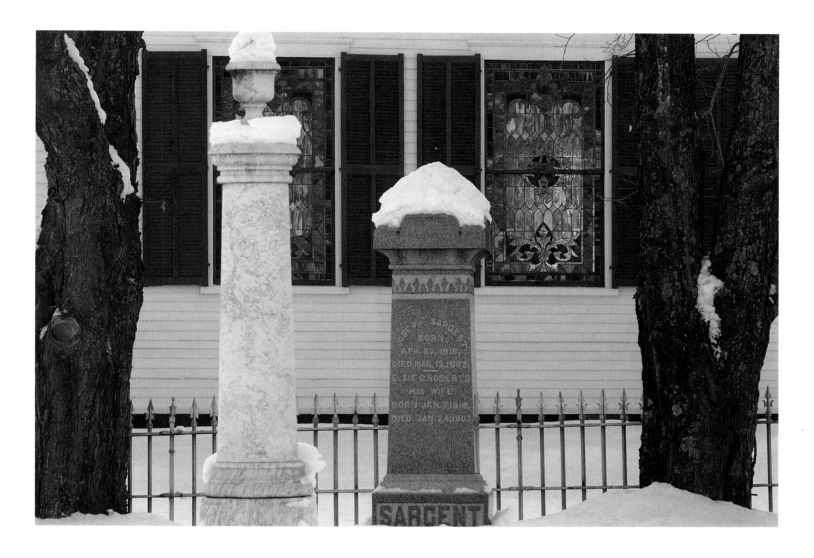

CHURCH WINDOW, VERMONT

The light illuminating this stained-glass window is actually the rising sun shining through the church from the opposite side. By moving to various spots in the graveyard, I was able to place the sun behind each window in turn, causing it to glow with a feeling of warmth on this twenty-below-zero January morning. The photographic challenge was to line up a few of the gravestones, the two tree trunks, the Victorian wrought-iron fence, one of the windows, and the sun on the other side of the church in a pleasing composition. It is important to realize that changing the camera's position by even a few inches can significantly alter the relationship of objects within the viewfinder—and the resulting effectiveness of the photograph.

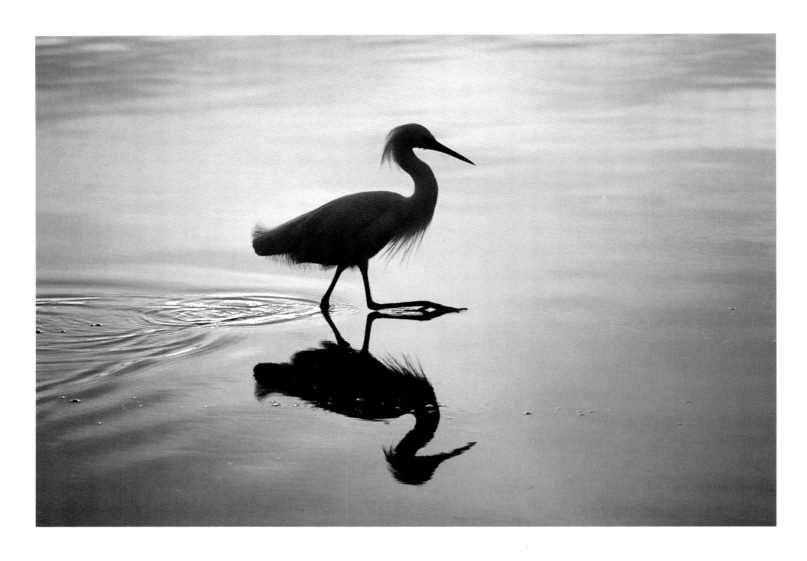

SNOWY EGRET, FLORIDA EVERGLADES

Ordinarily, early afternoon light is not good for photography, but on this day, thin clouds had begun to obscure the midday sun, resulting in an unusual veiled light that still provided some highlights in the water and a dramatic silhouette of the egret. When I faced the sun directly, the water had a molten, quicksilver quality, and the ripples caused by the bird's wading picked up a golden sparkle.

To preserve this lighting as I followed the egret along the shore, I had to keep constant both the angle of the bird to the sun and that of my 200mm lens to the bird. This was a challenge as the egret was wading quickly and the shoreline was deep mud. In this situation, you must keep your wits about you, as one misstep could result in a submerged and ruined camera.

CUMBERLAND ISLAND, GEORGIA

Keep your eyes open to any unexpected possibilities that light may create.

I originally went to this beach for the sunset, hoping that some unusual cloud formations might produce a picture with more personality than the typical postcard shot. Then, just as the sun was about to touch the water, I happened to glance down at my feet. I saw that the extreme low angle of the light on the wind-blown pattern of sand and shells was creating long purple shadows, which add depth to this photograph. This delicate sidelighting lasted only a minute or two, but that was long enough for me to reorient my thinking, choose the appropriate lens, and make several exposures.

No special equipment is necessary for a photograph like this, just a normal 50mm lens, a tripod, and an open mind.

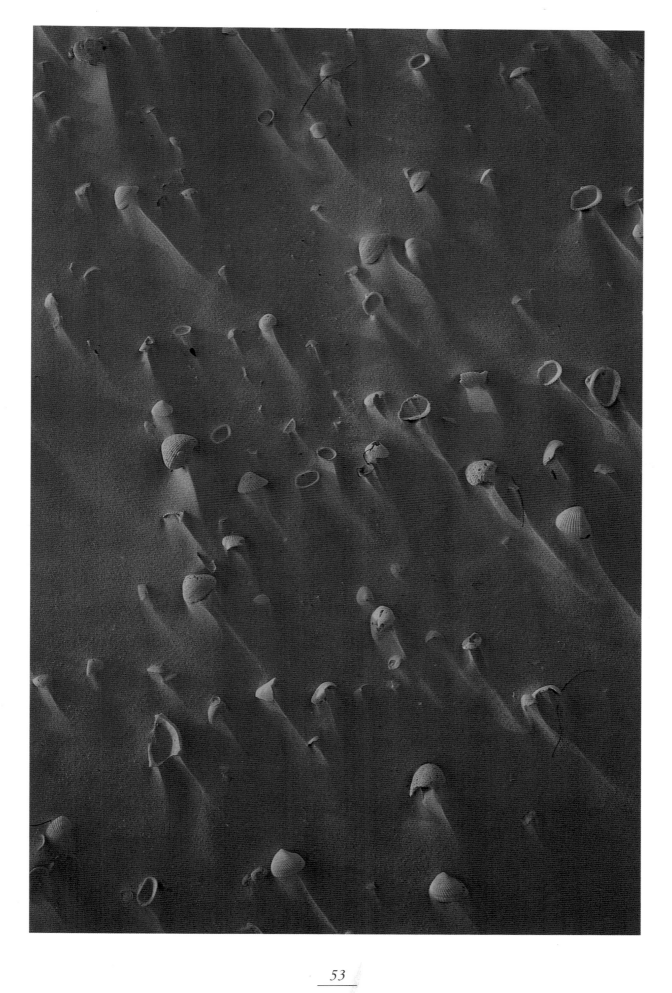

CHURCHILL'S BARN, VERMONT

When I took this photograph of a Vermont farm, bands of late afternoon sunlight and cloud shadow rolled across the land like giant waves. The sun was behind me, casting a flat light on the barn—light that would have been relatively uninteresting if it hadn't been juxtaposed with the massive inky shadow at the base of the picture. In this situation the most critical choice was when to trip the shutter and freeze the moving line that separated light from dark.

After taking this photograph, I turned in the opposite direction and faced the sun, photographing shafts of light breaking through the clouds and backlighting objects in the landscape. The "Holy Grail" effect produced results that were too melodramatic for my taste, but I'm glad I tried. It is a good idea to ignore prejudices and preconceived notions when photographing. Limitation can lead to stagnation. Besides, the wastebasket is a good teacher.

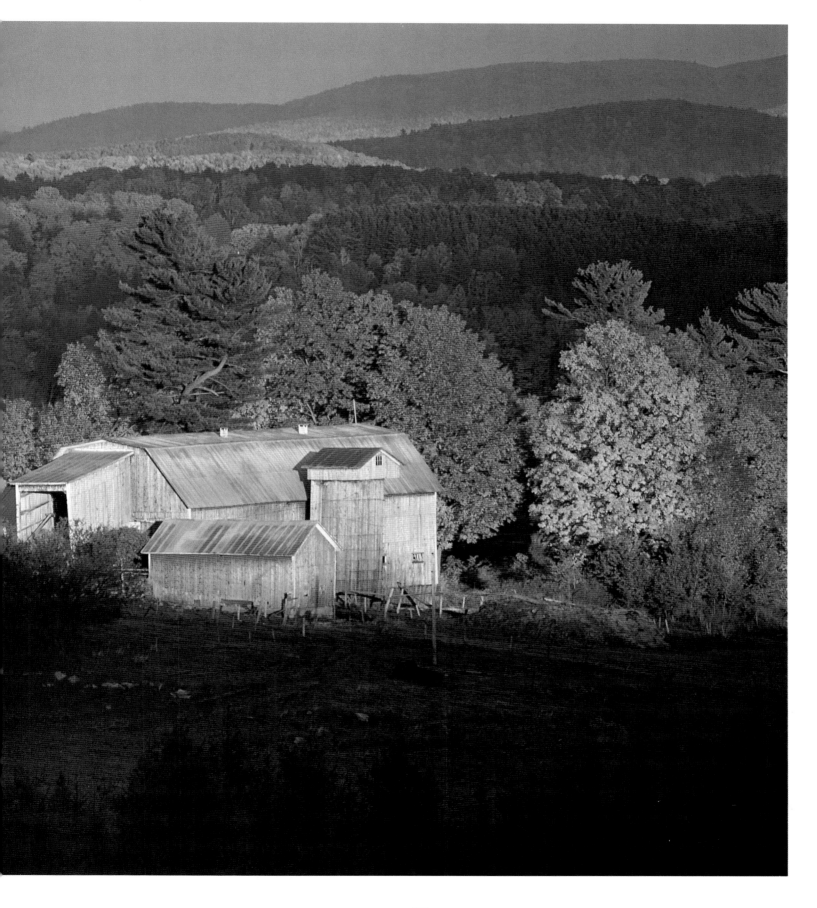

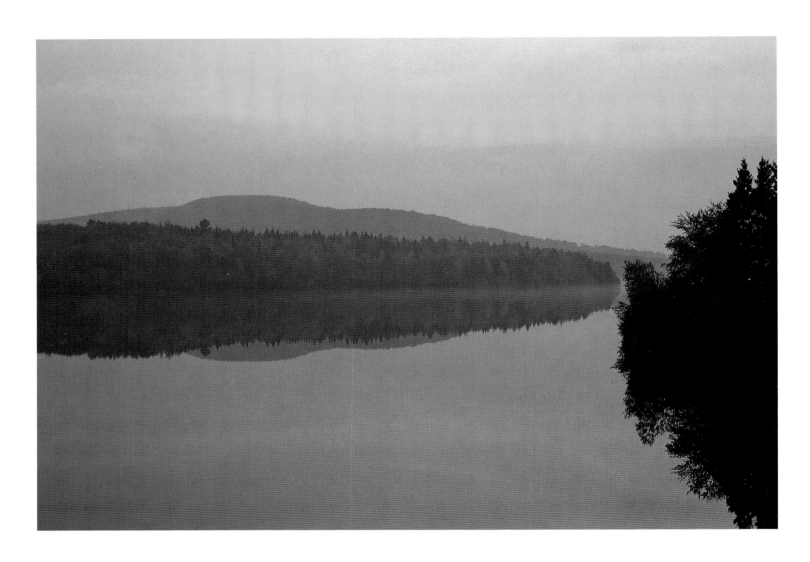

MOLLYS FALLS POND, VERMONT

This photograph was taken after the sun had set and an even, pink light lingered. I was intrigued by the simple double images—like Rorschach ink blots—echoing one another. I also wanted to show how the closeness in tone between water and sky made these shapes seem to hang in space.

There is an infinite number of changes in the quality of light at sunrise and again at sunset. Many times the most effective photographs are taken at dawn before the sun has appeared, or in the evening well after it has set. Don't make the mistake of leaving a location simply because the sun has dipped below the horizon. Wait and see how the fading light continues to transform the subject and alter the mood.

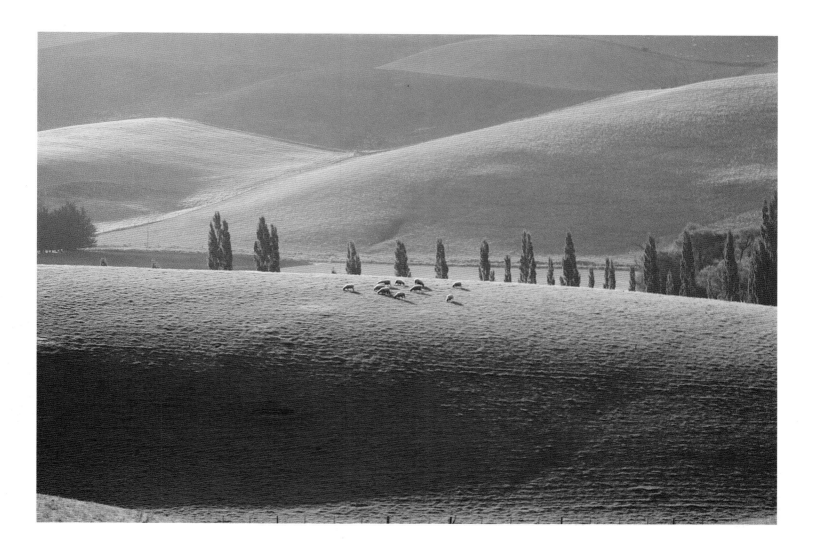

CANTERBURY PLAINS, NEW ZEALAND

The softly contoured hills surrounding Christchurch, New Zealand, were bathed in a hazy midafternoon light when I took this pastoral photograph. I often try to make the best of such light by choosing subjects that are backlit and by using a long lens—in this case a 200mm telephoto—to emphasize the quality of the atmosphere and to pick up any hints of texture. The long lens also compressed the distance between the flock of sheep grazing on the nearby hillside, the plume-shaped poplars parading through the middle ground, and the chocolate-colored plowed fields in the distance, heightening the sense of volume inherent in this landscape and emphasizing the roll and swell of its smoothly rounded forms.

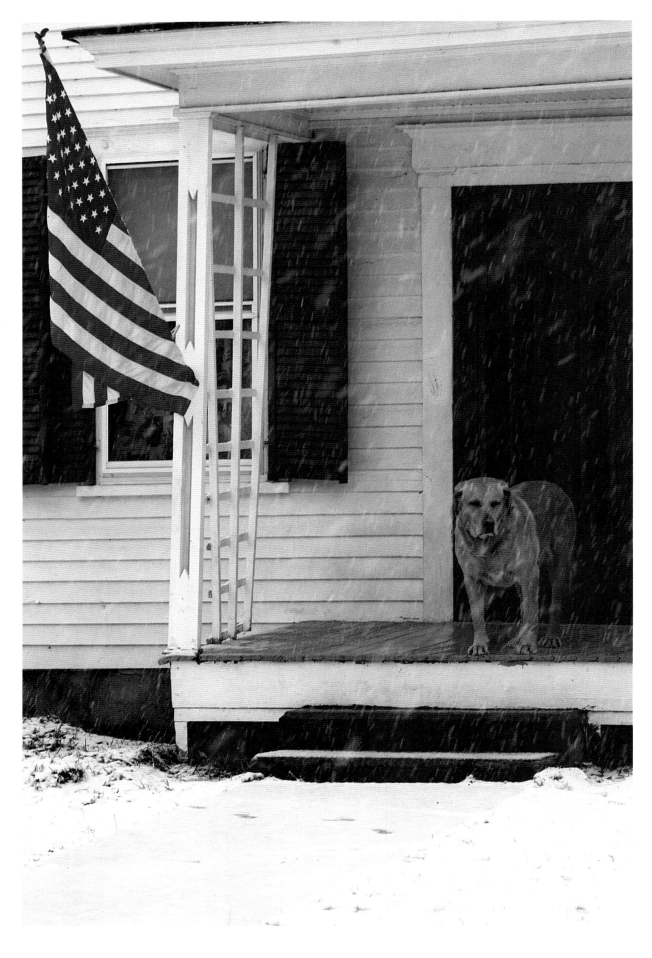

Weather

Imagine the kind of day that is revealed in the accompanying photograph. It is January. Snow is falling, wet and cold, and the world is muffled and still, except for the distant scraping of the town plow on the main road. Hardly inviting weather—even the stoical dog is reluctant to leave the familiar shelter of the front porch. This is, however, exactly the sort of day that begs for investigation with a camera. The least tempting weather can make the best photographs.

Given a choice, I would rather photograph in snow or rain—provided it's not torrential—or, best of all, fog, than under the azure sky of a perfect day. Bad weather adds drama and singularity to an otherwise mundane scene. An overnight blizzard transforms trees into strange giant corals. The alchemy of an ice storm changes the dullness of late November into silver. Shrouded in fog or beaded with drops of heavy rain, home ground becomes unfamiliar and exciting. Adverse weather challenges us and shakes us out of habitual ways of seeing.

Readiness and quickness are important in photographing the fleeting effects of weather. A rainbow lasts only a few moments, frost rapidly melts in sun-warmed air, and the snow that clings to tree branches soon blows away. You need to develop an instinct for anticipating when and where such conditions might occur. I constantly listen to weather reports, and equally important, I have familiarized myself with my area so I know where good shooting will be when striking conditions occur. It is frustrating to be searching for an appropriate setting when a breathtaking phenomenon is appearing before your eyes.

Fog offers some of the most photogenic effects, whether it is a thin layer alternately revealing and obscuring the landscape, or the heavy, pea-soup variety. It is also a condition that film captures particularly well. The delicate colors and muted brightness of the sky reduce contrast to a range that color emulsions can easily handle. Woods are difficult to photograph whether the day is sunny or cloudy, because areas of sky that are visible through branches or leaves are overpoweringly bright in contrast to the trees themselves. A forest bathed in fog or mist, like the one on pages 70-71, becomes a more rewarding subject because these splotches and dots of distracting brightness are replaced by an even, pearly light.

Although fog lessens the feeling of depth in a scene, some sense of distance is

DOG DAY IN WINTER, VERMONT

The expression on this dog's face says much about winter weather. Nevertheless, days like this are ideal for capturing the feeling of January. Stormy days often yield better pictures than days of sparkling blue and dazzling white.

The flag contributes a good deal to this picture. It balances the figure of the dog, adds a touch of needed color, and by its furled, listless form enhances the mood.

indicated by the gradual lightening in tone and increased indistinctness of objects as they recede into the murk. A photograph taken in an old graveyard, for instance, where the distinct color and texture of nearby headstones is clearly revealed while those in the distance grow progressively more ghostlike, makes the most of this effect.

Rain is a mixed blessing. A light rain doesn't bother cameras, but in a downpour they should be protected. I have gotten along by simply using a plastic bag with a hole torn out for the lens to poke through, but an umbrella works best. While I was growing up, I would rather have spent a week at the dentist's office than be seen carrying an umbrella, but I have since discovered the umbrella's true worth and always keep one packed in the same case with my tripod for working in wet weather. Umbrellas provide a workable dry zone for both camera and photographer, offering essential cover while you change film in the rain, and they take care of the maddening problem of raindrops on eyeglasses or the viewfinder.

Wetness enriches colors, especially in the fall when wet leaves look as if they have been freshly varnished, and the rain-soaked ground and stone walls make a somber backdrop for the brilliance of autumn's leaves. A "lashing" rain, as the Irish call it, may be too much to contend with, but when it subsides, puddles and rain-slicked roadways are good places to look for appealing reflections, and potential subjects, such as the wild iris on page 64, will be glazed with beads of water.

Snow and the cold that comes with it bring a different set of problems and possibilities. Cameras become sluggish when temperatures reach zero and below. Take care to advance and rewind film slowly, as it becomes brittle and snaps easily. If cameras and film get stiff at minus 20 degrees Fahrenheit, fingers become even more so. I have tried every kind of glove and mitten invented and still end up yanking them off when in the thick of shooting. The only kind that allows the necessary dexterity are thin gloves designed as liners; silk ones are the warmest. Also, my mother's admonition that wearing a hat would keep my hands warmer, like most of her unheeded advice, turns out to be true. Umbrellas, hats, and silk gloves—my worst high school nightmare!

In snow, as in rain, you may have to protect your equipment, but usually you can brush the snow off easily as you are working. I've dropped cameras in the snow, fished them out, blown the drift out of the lens, and gone on photographing. Don't leave equipment in a cold car overnight, however. It invariably frosts up when you take it out to shoot the next morning, because the camera is even colder than the outside air, contrary to what you may think. This condition renders your camera unusable for a good half-hour or more, and while it doesn't cause any lasting harm, it is immensely frustrating if you have wakened to the best snowstorm of the winter and everywhere you look there is something to photograph, but you are unable to capture the scene.

The choice of shutter speed will significantly alter the appearance of falling snow in your pictures. Speeds of $\frac{1}{125}$th of a second or faster will stop any motion, making a photograph with a pattern of small white dots. Slower speeds create long trailing streaks, and speeds in the range of a full second blur drifting flakes into a general foglike haze.

When my older daughter was three, she confessed to waking up on Christmas

morning when it was still "blue-early" outside. This unique light is caused by snow reflecting the first glow in the sky, and it is one of winter's gifts to photographers. Snow cover means increased visibility of the landscape at dawn and dusk. Photographs taken at these hours show barns or trees or fencerows clearly and beautifully revealed in the ice-blue light. These details would only be dark silhouettes at other times of the year.

Weather can in fact be more of a problem for a photographer when it is good than when it is difficult. I remember a particularly stunning day when I was taking pictures of a neighbor and his team of Belgian workhorses gathering sap for maple syrup. It was the kind of day that occurs in Vermont sometime in March, when the sun first feels warm on the back of your neck and you know that spring might actually happen. Man and beast were glad to be alive, and the farmer remarked that his horses were "full of piss and vinegar" as they plowed through the mealy snow. Chickadees were singing their three-note courting song, miller-moths were much in evidence, a sure sign of winter's end, and everywhere the sap dripped merrily in the buckets. As if this weren't enough, a skein of snow geese appeared flying in a line over the brow of the hill; they were so low that we could hear the wind whistling through their pinion feathers as they pumped their black-tipped wings in rough unison. As they faded in the northern distance, I turned to the farmer—bib-overalled, lantern-jawed, the laconic last of a breed—and exclaimed at the glory of the day. He peered up at the endless blue overhead and said, "Too damn nice!"

I suppose what he meant was, things couldn't get any better so they could only get worse. But as a photographer, I have come to appreciate the irony of his phrase. Some days *are* too damn nice for photography, days with the piercingly blue, cloudless skies of a high-pressure system fresh from Canada, days that are invigorating, inspiring, and life-enhancing—unless you are trying to photograph. The lack of any softening haze, the intense, almost metallic light, the cavernous inky shadows, and the good stiff breeze that are associated with this kind of weather—all spell doom for the photographer. I have learned that there is no filter to counteract this condition, no film that will make it work.

I accept the situation with as much dignity and grace as I can muster, quietly fold up my tripod, pack up my gear, and head over to the lake for a swim or back to the farm for some long-neglected task. One lesson all photographers must learn is knowing when to quit, and I suspect that too-damn-nice days are nature's way of reminding us that some things are meant to be enjoyed that much more because they can't be photographed.

RAINBOW, FRENCH WEST INDIES

There is no special trick to photographing a rainbow, other than being there when it appears. Because of the rainbow's magical nature, a great many people think one can't be photographed, but if you can see it, you can photograph it.

Moreover, it's not difficult to anticipate where a rainbow will occur. There is a particular kind of day that breeds rainbows, when the weather is prone to rapid shifts between sun and showers. A rainbow will only occur in the part of the sky that is opposite the sun; look for one when the sun is shining at your back and the sky before you is filled with rain. In my experience the most spectacular ones happen at sunrise and sunset.

If you want to photograph rainbows, pick out a few nearby locations in advance, so that when the weather looks promising you can reach a spot quickly as the first faint bands of color start to appear. By being prepared you can avoid the frustration of watching a spectacular rainbow shining over a tangle of telephone wires or other unlikely pot of gold that destroys the possibility of a good picture.

The rainbow in this image arrived without warning. I couldn't place it much closer to the center of the frame because an unphotogenic hotel stood to my right. Rather than be timid about it, I decided to make the rainbow arc precisely out of the upper right-hand corner and to balance it with the expanse of space to the left. This composition made a slightly lopsided but dramatic image.

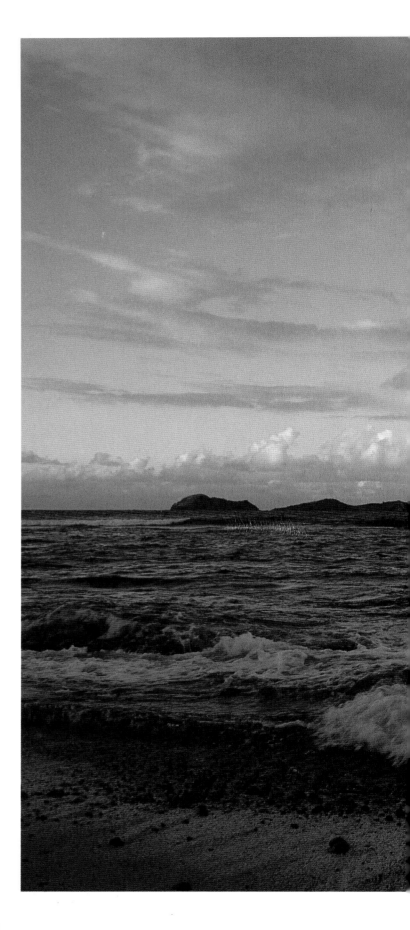

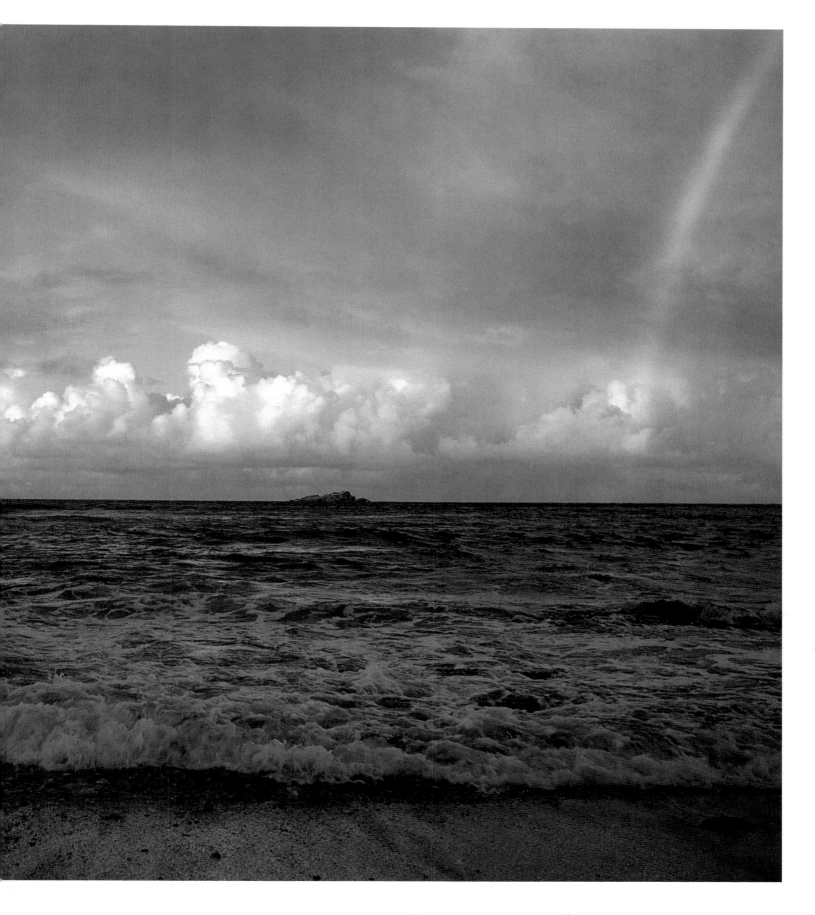

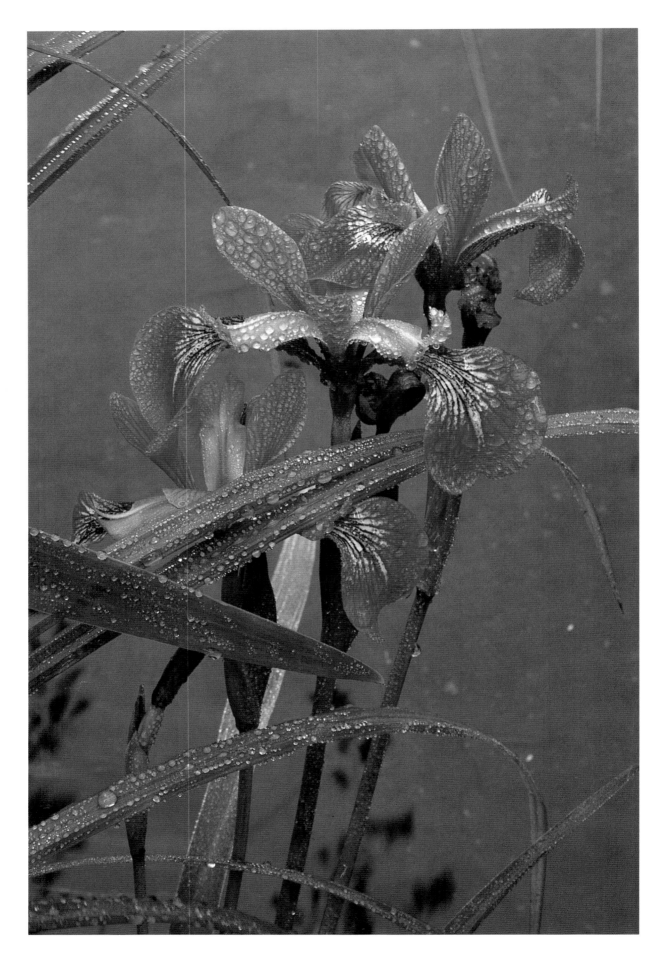

WILD IRIS, VERMONT

These iris were growing at the edge of a pond, so I was able to use the water as a backdrop and concentrate on the upright purple flowers and the arching green leaves. This photograph was taken during a soaking rain, and everything, including the photographer, was wet. While shooting, I held a large umbrella over the camera and the iris. I needed to protect the equipment and to prevent the falling rain from causing the subject to move. A 105mm lens at f/22 with a one-second exposure gave adequate depth of field and razor sharpness.

CLEARING STORM, VERMONT

The storm had raged all day, and I was snowbound, looking after my two young daughters and enjoying home and hearth. Then came a hint of clearing in the west and a growing pink light that I couldn't resist. I knew an ideal spot not far off where I could capture this situation, so I set a new record for getting two toddlers into snowsuits and loaded into a car. Fortunately they were used to their father's sudden attacks of photographic fervor and enjoyed these unexpected outings. I sped toward my destination, arriving as the immodest color was beginning to fade, but catching this final, understated flare of pink. My children indicated their appreciation by sucking their thumbs with increased intensity. Taken with a 55mm lens.

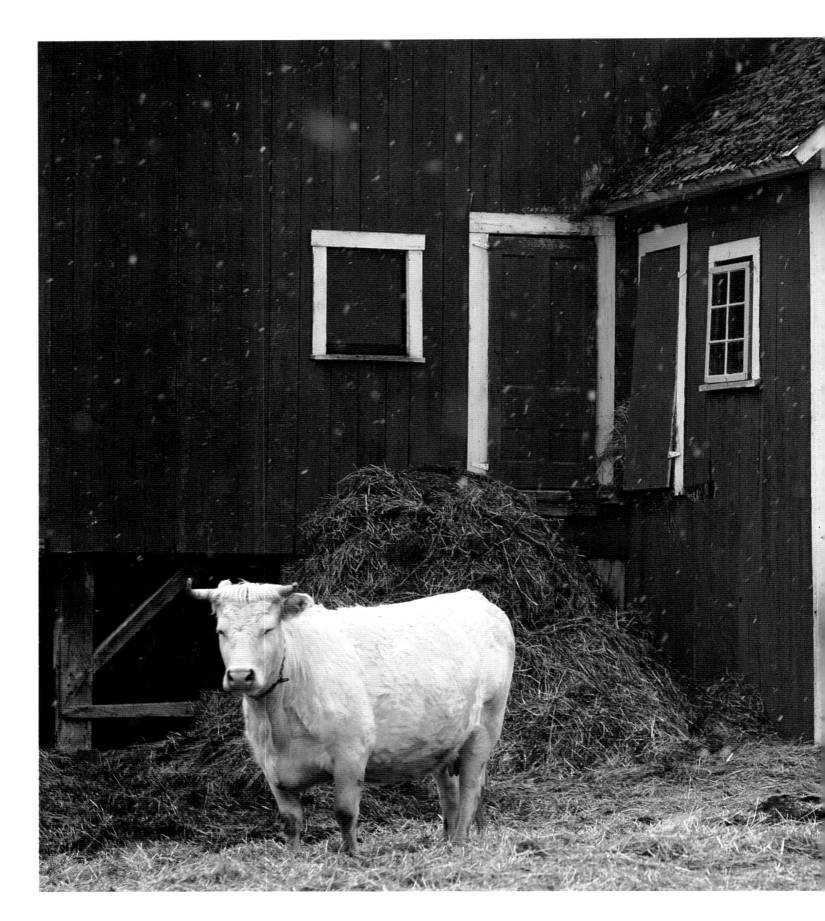

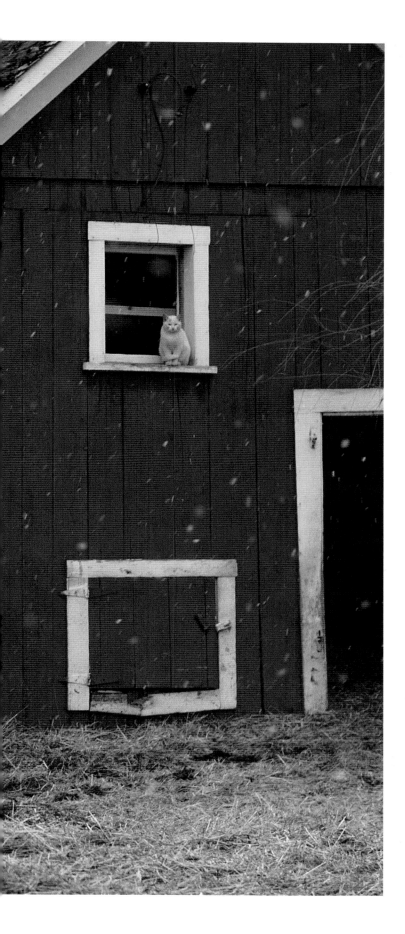

CHOATE'S BARNYARD, VERMONT

A cow and cat steel themselves against the approaching season, as the first few flakes of snow appear. A 105mm lens and shutter speed of ⅛₀th of a second recorded the falling snow as soft dots of white.

After poking around this barnyard looking for possible subjects, I tried this cow with its look of sleepy resignation, but I couldn't do much with her; something was missing. As I took my parting photograph, a cat unexpectedly climbed out onto the window ledge and sat with characteristic tail-wrapped-around-legs pose. Now the picture was complete: a white cow and a white cat, white barn trim, and white snowflakes drifting toward the ground.

Chance played a major role in this photograph, as it does in many. However, chance can only smile at you if you are looking for it.

TWENTY-FIVE BELOW, VERMONT

This photograph is an example of the "blue-early" light produced by clear weather, snow cover, and a winter's dawn. It can happen in the evening as well. The small bit of warmth glowing in the farmhouse windows makes the icy surroundings seem that much colder. I had to climb off the roadway to get the best camera angle. Tripods are notoriously unstable in deep snow, so I had to trample down a small area to make a firm footing. When the weather is frigid, don't forget to advance and rewind film slowly, or it may snap.

MILKWEED, QUEBEC

Wisps of milkweed down lie locked in place by a hard freeze. Frost has a singular effect on the myriad details of nature, unifying them with a coating of silver. In this picture, what would normally be a jumble of unrelated textures and shapes is integrated by the skin of ice. Frost doesn't require any special approach other than speed. It is one of the shortest-lived of weather's offspring, and sunlight is its undoing. For this photograph I chose a 55mm lens and used my shadow to provide even lighting and gain a little extra time.

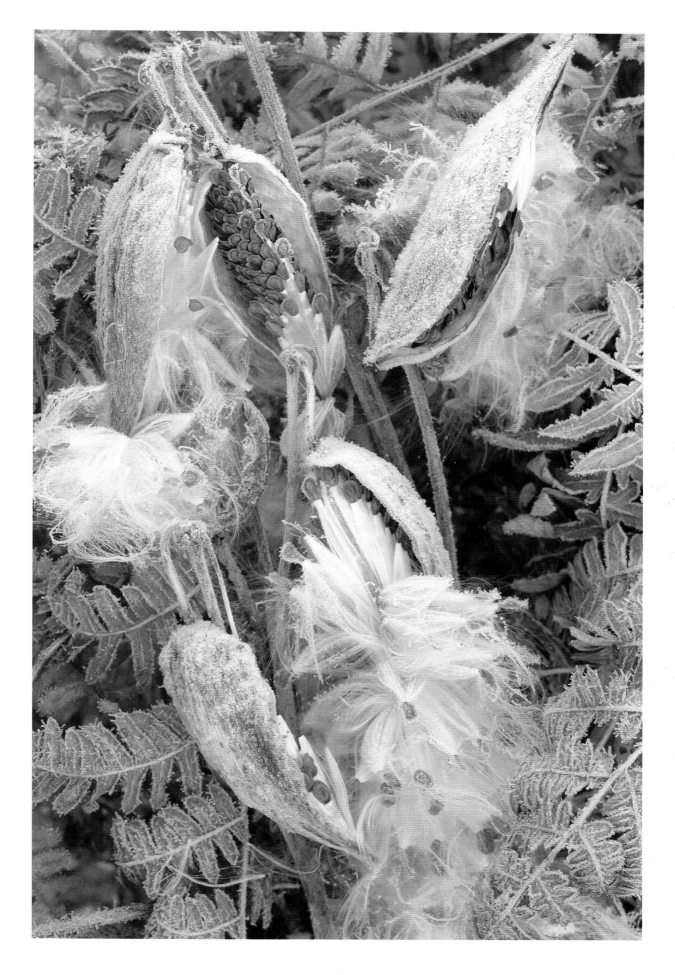

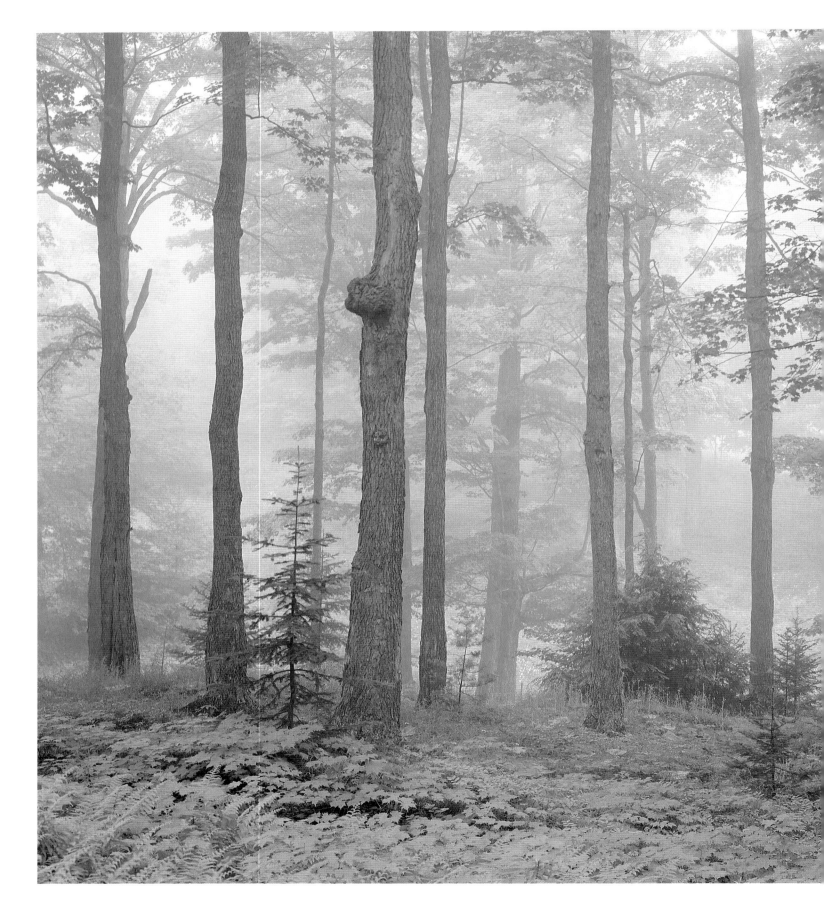

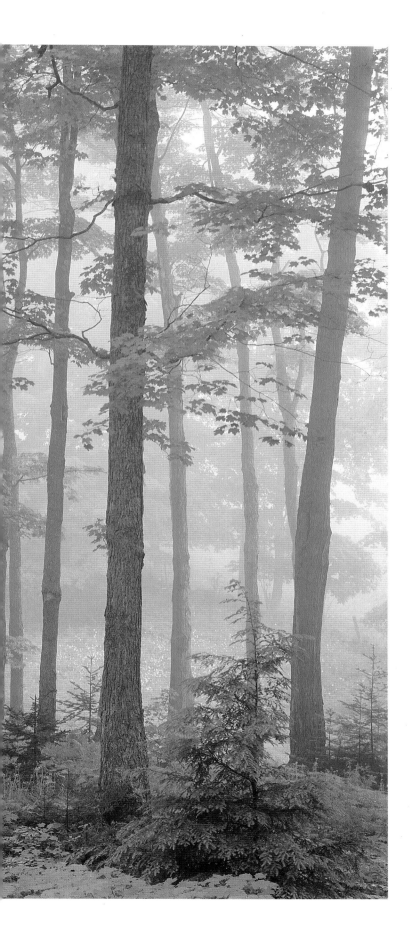

MAPLE ORCHARD, VERMONT

Summer fog casts its spell on a stand of sugar maples in this picture. The pearly light complements the muted shades of green; even the tree trunks have a greenish cast. When shooting branches against bright fog, you will have a tendency to underexpose. Here, I opened the lens a half-stop from the indicated exposure to preserve the pale, misty effect.

Foggy mornings are not only beautiful, but still. Ferns and cobwebs and dandelion seeds that are usually agitated by the wind can be photographed with small apertures and long exposures for maximum sharpness. The leaves on these branches held absolutely still for a two-second exposure.

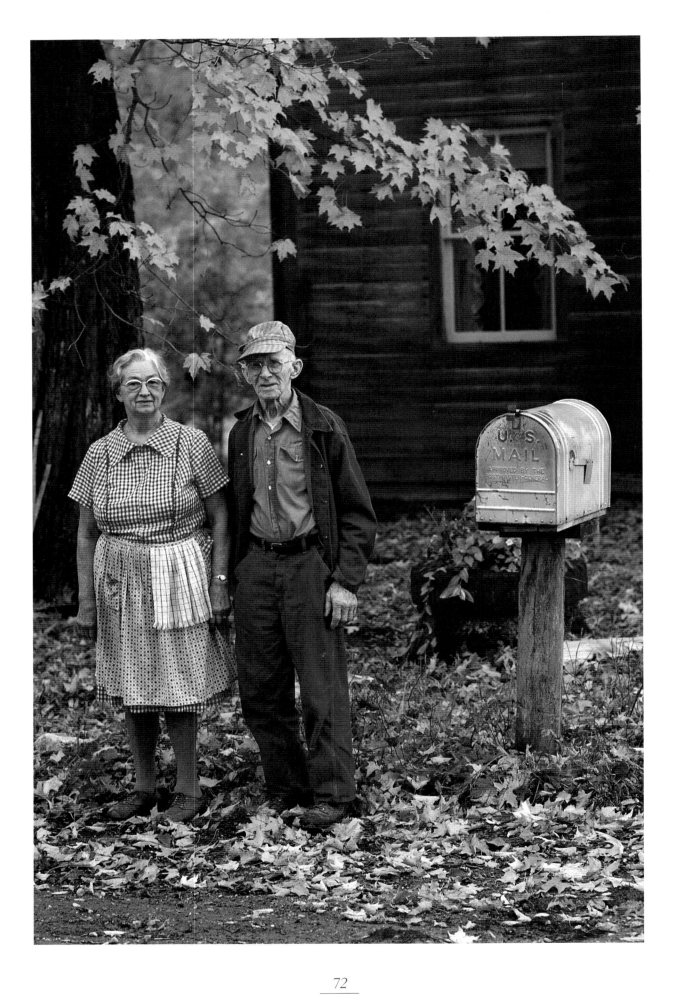

People

Different people act differently in front of a camera. Some stand stiffly at attention, others smile self-consciously, many blink, and children either show off or hide. We all share a fear of being discovered in our full imperfection by the camera's impartial probing eye. To get photographs that capture more than this basic anxiety, you must be persistent and sensitive, and have an instinct for finding moments when character outshines unease.

There are times when an individual's exaggerated sense of self-presentation is fascinating; or the mask he assumes when being photographed may be well worth recording. But the greater challenge is capturing the spark of true personality that lies behind this forced outward appearance. To build trust and create a situation in which people will drop their masks, photographers have to be secure in their own role. If you are uncomfortable, the people on the other side of the lens will also be ill at ease. In fact, your ability to relate to others, to gain their confidence, and to allow them the freedom to be themselves is far more important than any technical consideration of lighting or composition.

Working with respect for the subject leads to trust. As photographers, we are intruding into other people's lives and are taking, if not their souls, then certainly moments that may reveal much about their inner selves. Something is given to the photographer; an exchange takes place, and the photographer's contribution should be one of consideration.

Trust is best built over a period of time, and when taking photographs of people that you know well, you can take this ingredient for granted. Working photographers rarely have the luxury of built-in trust, however. The elderly couple shown on the opposite page were photographed for a magazine assignment after only a brief conversation. Because we had just met, I decided to include parts of their surroundings to help indicate character. In a sense, this photograph was arranged, but with respect for the subjects' way of life and not in an overly stylized way. I brought them together to this spot from their respective morning chores—she from the kitchen, washing up the breakfast dishes, he from the henhouse, gathering eggs. The unpainted, aged siding of the house, the venerable maple, the old tire set on a stump for a planter, and the mailbox scratched and worn by countless openings and closings formed a setting that spoke of lives lived unpretentiously and of time's passage.

ANNA AND PAUL FENTON, VERMONT

A mailbox, "Approved by the Postmaster General," is a mute third party in this photograph, but it serves an important role in the composition by balancing the elderly pair. The matching dark tones of the tree trunk and house form a green channel that directs the viewer's eye toward the couple; the somber tones also serve as a backdrop for the bright spray of leaves. I used Kodachrome 25 film to bring out the subtle orange of the foliage.

They told me this day was special. It was their fiftieth wedding anniversary, and a family celebration was planned for later that afternoon. To my eye, their identical stance bore testimony to this milestone. I pressed the shutter release as they posed in union, both leaning almost imperceptibly in the same direction, shaped together by a half-century of life's good and bad weather, and held in place for this brief instant by the arch of fading leaves on the branch overhead and the pool of fallen leaves on the ground.

A good portrait is usually something that the photographer builds toward and is achieved after some preliminary interaction and experimenting. At a portrait session I often take an initial roll of film without any expectations, just to relieve tension. One memorable exception to the success of this method occurred when I was photographing a gathering of Hell's Angels at the motorcycle races held each June in Loudon, New Hampshire. One biker in particular stood out, even in this crowd of extroverts. He was huge, swathed in black leather and chains, tattooed, earringed, and bearded, with a massive bared chest and a sumo wrestler's belly hanging nicely over his studded garrison belt.

"Could I take a picture?" I asked with some trepidation. He nodded. Inspired, I fired off half a dozen frames. Suddenly my Nikon was firmly removed from my eye and replaced by his glowering face only inches from my own. Total silence. Then, in a voice just above a whisper, he rasped, "You said *a* picture!" Clearly I had not established an adequate amount of trust.

Asking permission before taking someone's picture is a basic courtesy. I have rarely been refused. Most people recognize that I make the request because they have a special quality that I am drawn to; the impulse to take their picture is a flattering one—even if the outcome is not. A pleasing likeness is not always the object of a good photograph; an honest, perceptive portrait is.

There are situations, however, when observing this courtesy is not possible—or even a good idea. When you are photographing people at public events—at a farm auction or a county fair—announcing your intentions can destroy opportunities. If your aim is to mingle with the crowd and unobtrusively find pictures of the small human dramas that unfold, drawing attention to your camera is self-defeating. The great French photojournalist Henri Cartier-Bresson speaks poetically of this approach: "Let your steps be velvet but your eye keen; a good fisherman does not stir up the water before he starts to fish."

I trust my instincts at these times. If I am noticed, or if my camera's presence obviously upsets someone, I stop and move on. I will often speak after the picture has been made, however, identifying myself and what I am up to, and offering to send a print to the subject. If you are thoughtful and direct, you will rarely run into hostility. I have been somewhat startled, however, by the number of people who ask not to be photographed because they are on the run from some minor felony or other indiscretion.

People generally appear more natural and are more receptive to being photographed when they are at work or are interacting with others. Under those circumstances, they are less conscious of the camera. Spending the better part of a day with a farmer mending fence, or with a veterinarian making the rounds, or with a mother and her children working in a garden will create many opportunities for photographing people absorbed in their work.

Movement and spontaneity are essential when you are trying to capture people's moods and actions. For this kind of photography, a tripod is a liability. Shooting needs to be loosened up, and flexibility and risk-taking should be encouraged. I recommend frequently changing perspective, moving in close to the subject and then pulling back. Investigate a variety of camera angles and distances. Get down on one knee for a while, or take advantage of anything that can be climbed for added height. Exploit the characteristics of different lenses. Use a wide-angle, for instance, to include the full scope of any action and its setting, like the two boys playing a game of backyard basketball in the picture on page 77; or try a telephoto lens to make a tighter image, emphasizing a person's expression, like the furrowed brow of the farmer holding his rabbit on pages 84–85.

A wide-angle lens used close to the subject will distort features and proportion. This perspective can be used to dramatize personality or action, but it should not be overdone to the point of being grotesque. Because the wide-angle lens is often used at close range, I tend to think of it as an aggressive lens, and I will warn you that if your subject is camera-shy, using this lens close up may drive him over the edge.

I think of a telephoto lens, which is generally used at some distance, as a passive lens. A telephoto will foreshorten and flatten the figure and eliminate background detail.

Since hand-held photographs of people require a shutter speed of $\frac{1}{60}$th of a second to avoid camera shake, and up to $\frac{1}{500}$th of a second to freeze rapid action, lenses have to be used at correspondingly wide apertures, and focus becomes critical. Normally, I try to keep the face, and especially the eyes, sharp—although there are times when a person's gesture, hand, or even turned back is the most expressive element in a photograph. Consider making a "portrait" of someone by leaving her face entirely out of the picture. In the photograph on page 78, I tried to show the mother's concern and love for her upset child by including only her reassuring hands. You can let the viewer imagine what the person in your picture is like by including just a part of the subject's body; this approach can add mystery to an image. The intent should be obvious and well composed, however. I don't recommend haphazardly beheading people or cutting off their limbs.

I have saved the most crucial element of photographing people for last: the importance of the moment. Effects of light and weather may last for minutes, but flashes of personality or the fortuitous interplay of figures within the frame occur only for an instant. Such moments are not mere split-seconds of time. They show meaning. Above all, they imply choice. Taking rapid-fire pictures with a motor-drive may produce thirty-six images of a person's likeness, but they are all random.

A photographer needs to develop a sixth sense for anticipating the half-smile, the frown, the outstretched hand—whatever momentary look or gesture embodies the individual. The finger's movement and the shutter's click become an instantaneous act of perception and affirmation. By seizing the telltale instant, we can capture a person's boredom or passion, his anger or love, his mask or candor.

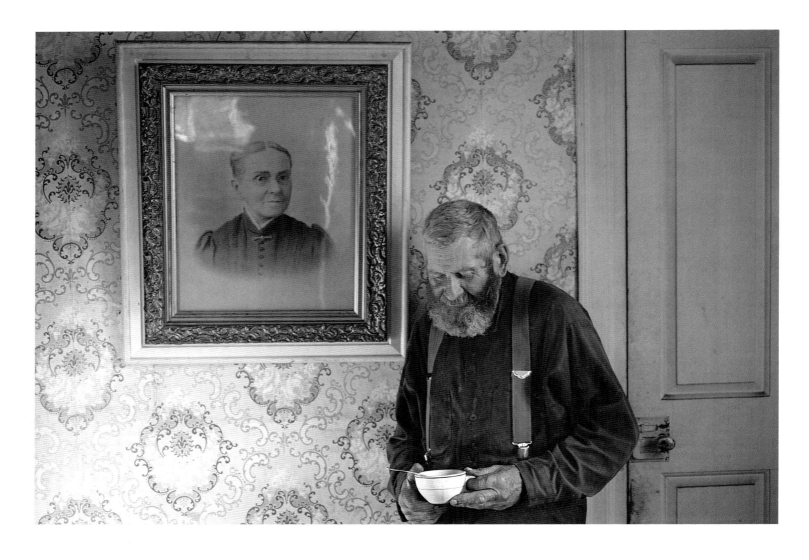

THERON BOYD, VERMONT

Theron was a shy and eccentric man, living alone on his ancestral farm as though still in the nineteenth century. He hauled his water by hand from a well in the yard and did his barn chores by lantern light. I made this double portrait of him and his grandmother with a 105mm lens, taking advantage of sunlight shining through a window and reflecting off the floor and walls.

I felt this was a special moment. Thanks to an earlier photographer I could see grandmother and grandson together at similar ages; their kinship is revealed in the slope of their shoulders, the broad nose, and closely set ears. There was one major difference between the generations, however: the eyes of the past stared back at the camera with an unwavering gaze; the eyes of the present were averted.

MUD SEASON BASKETBALL, VERMONT

Clear weather, a drab time of the year, and noontime light normally conspire against a good photograph, but for me, they work in this picture. Here the intensity of the shadow accentuates the subject. The boys' darkened outline stands out against the bright sky and landscape. The sleds point toward the action and echo the two figures.

I chose a crucial moment to freeze the action. In the player's outstretched arm and the ball poised above the basket you can see the flow of the game compressed into one instant. You can feel the inevitability of the ball's dropping through the rim. If the shot had missed, the picture would have, too.

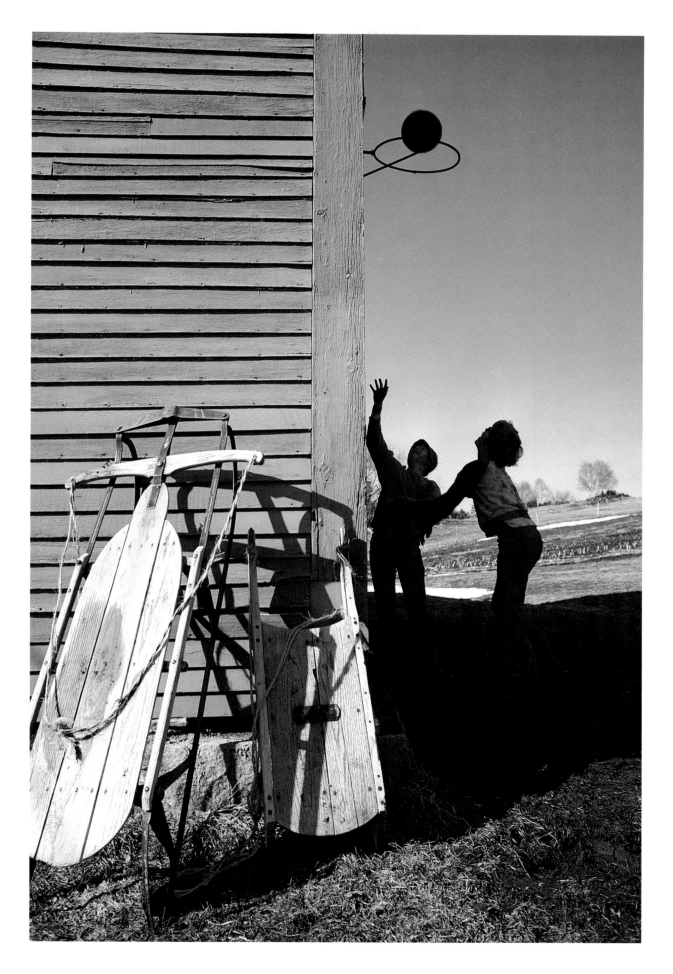

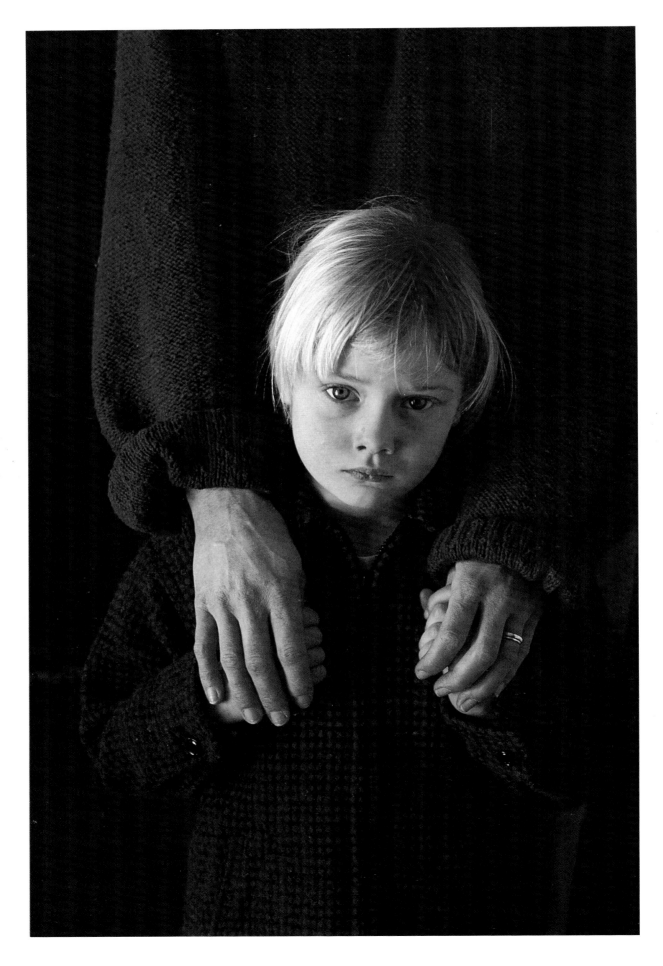

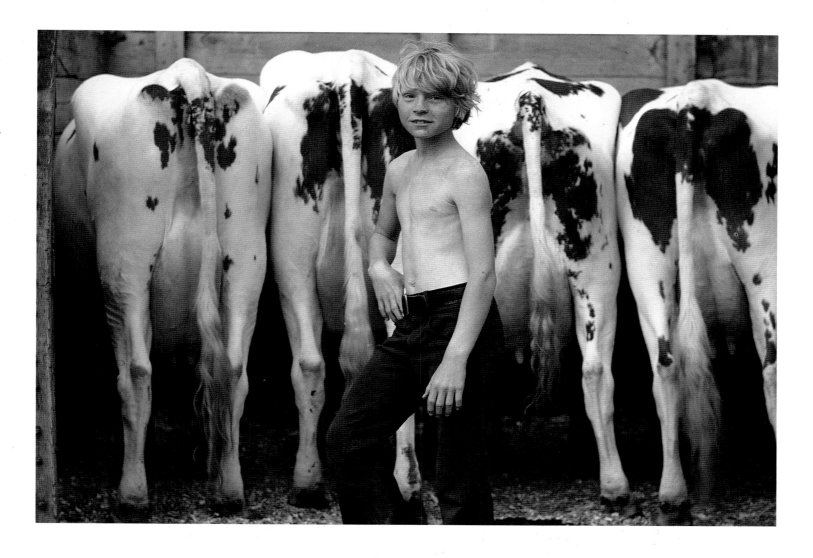

TESS, VERMONT

This child was caught at an unhappy but irresistible moment. I left the face of the mother out of the picture because it would have drawn attention away from the child's expression, but the mother's hands were a welcome element, communicating reassurance in a quiet, unobtrusive way. In photographing people, gesture can be as important as countenance. Because I wanted to make the skin tones shine out, I underexposed by a half-stop to darken the surrounding clothing.

TUNBRIDGE FAIR, VERMONT

Now here is a photograph filled with subtle rhythms and echoes. This boy was loading his blue-ribbon Ayrshires onto a farm truck when he turned and mugged for the camera. Fairs, where everyone is in rare good humor, are great locations for spontaneous, hand-held photography. For this kind of work, I often keep two cameras ready, one with a 28mm lens and the other with a 105mm, which I used here. This way I can cover a variety of situations and not miss an opportunity because I have to change lenses.

RAKING HAY, VERMONT

A portrait doesn't have to be a straightforward, head-and-shoulders view. I don't like to define the concept that narrowly. In this instance the man's face is indistinct and yet much about him is revealed. The relaxed shape of his body shows his years of experience handling a team. The repaired dump rake in the foreground tells us that he's spent a lifetime making do, and the thinness of the hay and of the horses indicates that he's eking out a living on these spare hills.

Whenever I am photographing someone, in addition to making a "normal" portrait, I like to back off and get a fuller picture of the world the person fits into. I also like to take the opposite tack and zero in on details. I took a close-up of this farmer's hands holding the reins, for instance. With a subject and setting as rich as this one, try a variety of approaches. I did photograph a standard rendition of this farmer, posing him with an arm resting against one of the horses' sweating withers, but paradoxically I felt this distant view offered a more intimate portrait.

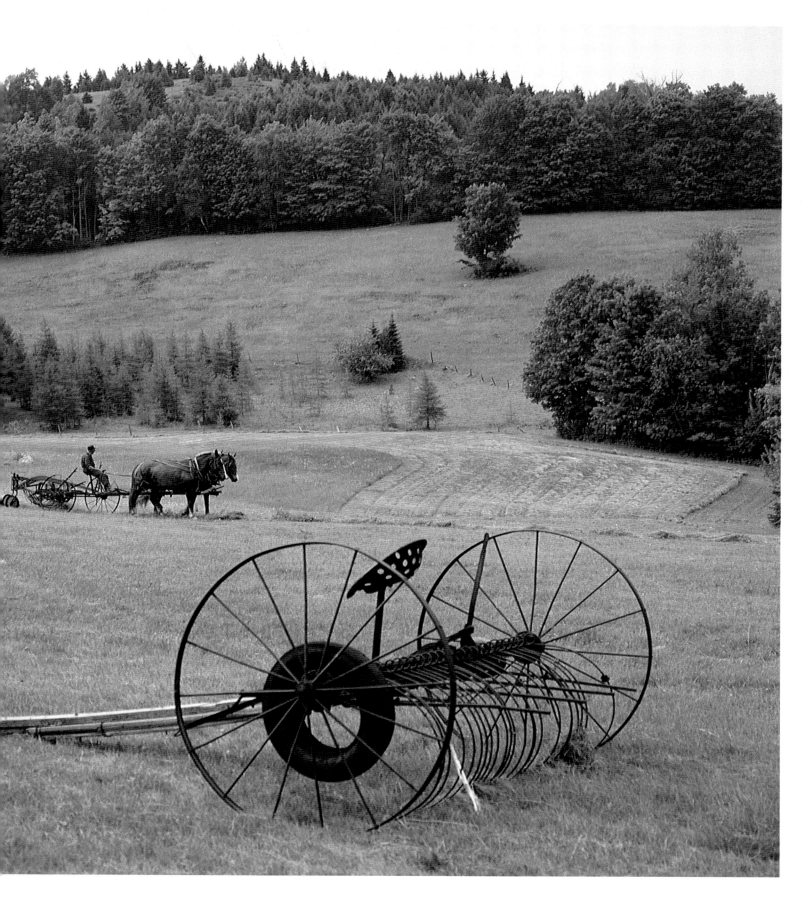

GATHERING SAP, VERMONT

Maple sugaring celebrates the end of winter. It begins with high spirits, but by the time the snow is melted and the sap tastes of leaf bud, exhaustion has replaced exhilaration. People at work are apt subjects for the camera. They are too busy to be self-conscious, and elements from their workaday surroundings can provide insight or irony. In this picture the convivial row of gathering buckets, tilted toward one another at conversational angles, makes an effective contrast to the solitary figure of the worn-out girl.

TOWN MEETING, VERMONT

Two elderly sisters give careful consideration to nominees for road commissioner, a decision with far-reaching consequences. Vermont towns are judged by their church suppers and the condition of their dirt roads. Small-town public events like this one are rife with Norman Rockwell-like moments. For this kind of hand-held, available-light photography, a large lens aperture is required, and focus becomes critical. Generally, I concentrate on the eyes. A 105mm telephoto lens let me single out this pair and remain at a considerate distance.

JOHN SOMERS, VERMONT

This portrait of a neighbor and his prized albino rabbit plays on our sense of touch. The rough, splintered barn boards, the flannel shirt worn smooth by countless washings, and the silken fur of the rabbit are strongly tactile elements.

John was the patriarch of local farmers. I caught this pensive moment when he was eighty-two and still spending all his waking hours on the tractor or in the barn. He had the rare quality of being totally oblivious to the camera; when I photographed him, I felt invisible. This day he took me on a tour of his barn, a Noah's Ark of domesticated animals adrift in a 200-acre sea of prime alfalfa. He paused to show off this quiet inhabitant, and I asked him to step toward the window opening for better light and a more forceful composition.

Note the frown. I didn't want the picture to be too saccharine. Another farmer in town used to start every morning with a shot of maple syrup and a pickled egg. The egg "cut the sweet," he said. This is a principle I've tried to remember, especially when photographing people. Smiling isn't mandatory. Given the nature of this subject, a kindly octogenarian holding a bunny, any smile would have made a cloying image. I cut the sweet by selecting a moment when John was slightly scowling, a moment in which, it happens, a similar expression was shared by the rabbit.

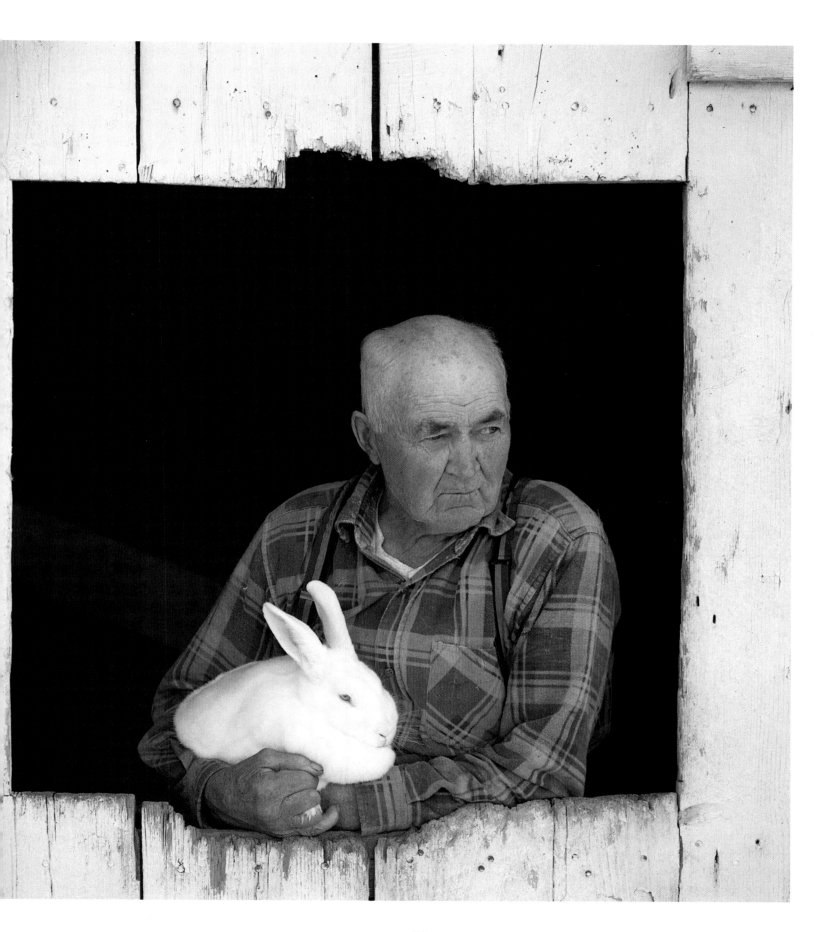

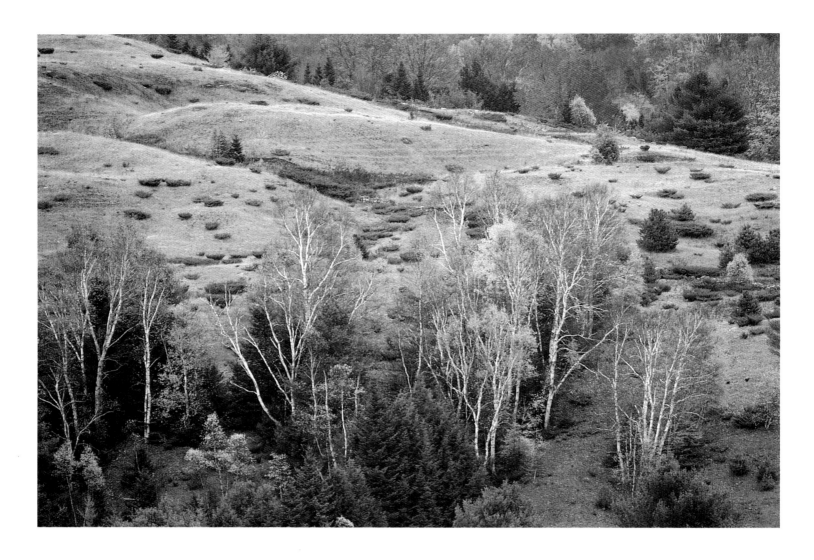

NICHOL'S MOUNTAIN, VERMONT

In this landscape, the remains of an old wall and faint cow paths running through the threadbare pasture contrast with the vigor of the advancing birch trees. Northern New England is filled with the ghosts of former hill farms.

This photograph was taken with a 200mm telephoto lens from across a narrow valley, which gives height to the perspective. Long lenses can be used to pick interesting elements out of the landscape, allowing for scrutiny of an eye-catching component when the entire view is too overwhelming.

Landscape

Beware the grand vista! Capturing the panorama is among the most difficult of all photographic endeavors. Success is sweet indeed, when it occurs, but frustration is far more common. Be especially wary of fabled views from lofty mountaintops.

Here is a case in point. A friend who is a logger by trade was adamant about showing me the view from where he was thinning a stand of white pine high atop Nichol's Mountain. There were some "wicked-good" photographs to be found there, he insisted.

I enjoyed the rough ride up the rutted trail in his four-wheel-drive pickup, redolent with the smells of pine sawdust, spilled coffee, homemade doughnuts, and chain-saw fuel. I enjoyed the fall colors and the conversation, which ranged from the mysteries of sharpening a saw chain to the mysteries of relating to the opposite sex. I particularly enjoyed the view from the summit—but I didn't take a single picture. (To be polite, however, I did pretend to take many.) As promised, grand scenery stretched to the horizon in ever fainter folds of ridge and valley. A good part of northern Vermont lay below, some of New Hampshire, and Canada as well. But to my eye there was no photograph. There was nothing to focus on, only awe-inspiring vastness reaching to infinity in the thin blue haze. What we so easily sense in person, the three-dimensional feeling of great height and distance, the camera has a cruel habit of diminishing and flattening. I couldn't see any clear subject, mood, or design here, other than a uniformly distant view, which I knew from experience would yield a disappointing photograph. The experience of being there was definitely exhilarating, but you can't photograph exhilaration.

Only at the bottom of Nichol's Mountain, after our descent, did I find something to photograph—groves of graceful white birches reclaiming the remnants of played-out pasture. In this more modest setting, I took the picture on the opposite page. Here I saw a forceful design and subject, the slender ghostlike birch trees dancing across the hillside like animated skeletons.

Landscape surrounds us, but unless provided with a focus, any picture of it will appear bland and meaningless no matter how much acreage or altitude is involved. Whatever element in the landscape catches your eye—whether it's the pattern of white trees on a mountainside or the shadows of cloud formations on the land—should be self-evident in the photograph. It shouldn't be overstated, but it must be communicated with clarity or the picture will fail. When photographing the landscape, where great space and complexity of view are commonplace, you need to keep asking yourself, what is it I am trying to show? What is the reason for this photograph? Once you have determined that, you can figure out how best to approach the subject. For example, it was the sense of movement in the birch trees that I wanted to show, so I composed the photograph with space at the right edge of the frame and included the open pasture behind the trees. If I had filled the frame with a

closer shot of just the birches, I might have dramatized their rhythmic alignment, but I would have sacrificed the fanciful impression of movement because there would have been no space for them to fill.

The focus of a landscape photograph doesn't have to be a specific object like these birches; it can be a striking visual design or the mood of the scene, but whatever you choose to record must be apparent to the viewer. The somber feeling of late November is the focus of the photograph on pages 90-91. Although a good deal of countryside is pictured, the elements used to convey the mood are simply organized in a straightforward manner. Bars of open land, woods, and distant farmscape give a dominant horizontal design to the photograph, while the narrow band of gray sky discourages any feeling of upward movement and reinforces the weighty mood of a dark November afternoon.

If you are having difficulty finding a focus in the landscape, perhaps you are trying to absorb everything at once and are being overwhelmed by the amount of visual raw material at your disposal. Try studying smaller segments of the terrain. Whenever I give a workshop in landscape photography, I have the class spend the first afternoon photographing an area no larger than a parking space, discovering rhythms, echoes, and elements of design that can be applied to the landscape as a whole. Start small and work toward an understanding of the whole.

Because a sense of distance is such an integral part of viewing the landscape, you should be familiar with approaches that add depth to a photograph. They should never be seen as cure-alls, however, or followed uncritically. Every subject deserves a fresh eye and an open mind. Using a wide-angle lens is the easiest way by far to increase the feeling of depth in an image. This effect is most pronounced when foreground elements only inches away from the lens are incorporated into the image along with the distant horizon. Don't be timid! The whole idea is to make that nearby rock or tree trunk seem immediate and touchable. The autumn photograph of the farmer crossing a leaf-strewn dirt road on page 93 was organized in this near-far manner. The combination of the nearby leaves and the diminutive figure of the man in the distance creates a powerful impression of depth. The leaves are especially effective because their scale is easily recognizable and their rapidly diminishing size as they merge into the background gives a forceful sense of perspective. Scale is used in a less dramatic but similar way in the photograph of a Yorkshire landscape on page 96. Here there is no faraway horizon to indicate depth, but the gradual decrease in size of the stone walls and barns conveys a feeling of distance.

Shooting through an object that acts as a frame or window is another way to add depth to a landscape. The postcard example of the overhanging tree that frames the distant scene has grown stale, but there are other more original possibilities that bear investigation. I have had good luck shooting through the lacework of a wrought-iron gate when photographing an old cemetery in South Carolina, or framing an expanse of Montana prairie in a section of barbed-wire fence. Needless to say, when you're including both distant and nearby elements in a photograph, small lens apertures are needed for adequate depth of field.

Photographers may feel powerless when facing a landscape that seems fixed and unchangeable. You can't ask a mountain to smile or turn a little to the right. One fundamental

aspect of the landscape that you can alter and use to your advantage, however, is the placement of the horizon. Where you set this all-important line of demarcation plays a major part in determining the emotions elicited by a landscape photograph. If the horizon is raised toward the top of the frame, the landscape will push against the remaining narrow edge of sky and a feeling of tension and force will result. On the other hand, horizons that appear in the middle of the frame cause feelings of equilibrium and calm, and those placed near the base of the picture turn our attention skyward, creating a sensation of spaciousness and freedom. Unless you are obviously trying for an effect, horizons should be kept scrupulously level. Crooked horizons indicate sloppy technique, and a seascape with the ocean slightly askew inevitably makes the viewer queasy.

One final decision that you have to make when photographing the landscape is whether to include the human figure. The presence of people in a picture makes a profound difference. No other element has such magnetism. No matter how small or insignificant the human form in a photograph, our eye rushes to it. People always become the center of interest in a photograph, and their presence alters our perception of a scene. The small figure of the bent farmer walking toward the barn in the photograph of the leaf-dappled road (page 93) adds poignancy and scope to the image out of all proportion to his tiny size. Without him, this picture would be just another scenic. His presence, however, enriches the photograph and underscores the harmonious nature of man's role in this quiet, fogbound landscape.

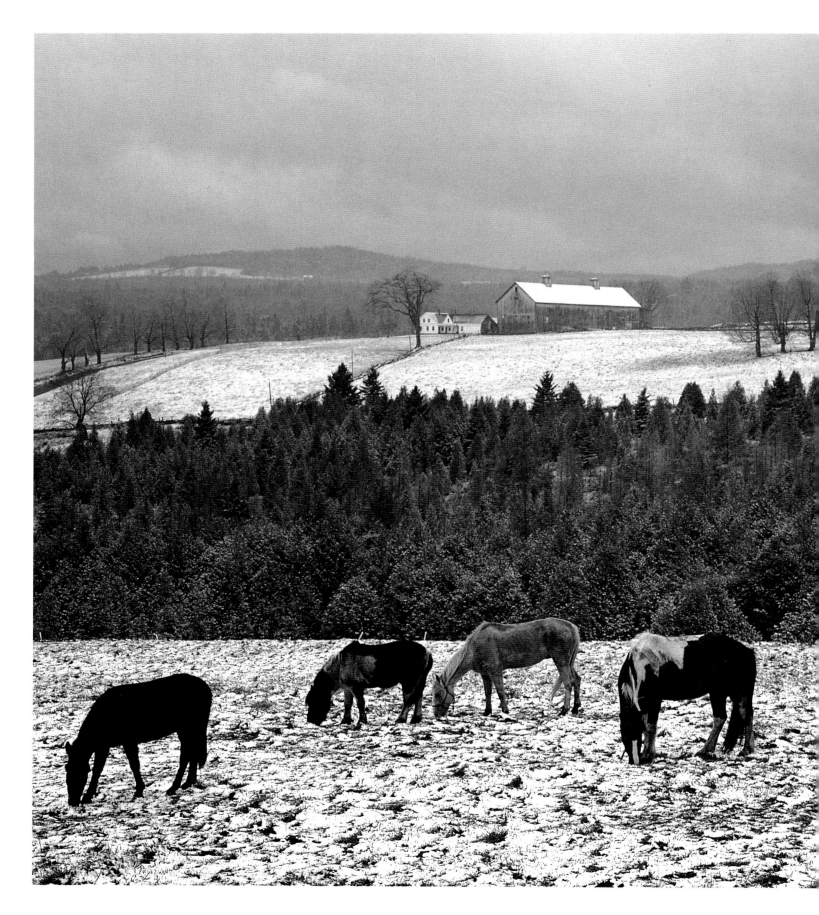

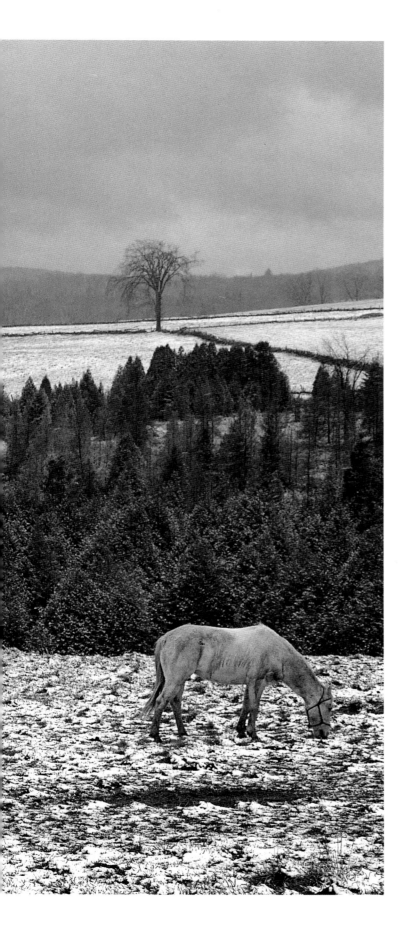

NOVEMBER LANDSCAPE, VERMONT

A pewter sky hangs over the close-cropped hillsides and leafless trees of November. The bones of the landscape—its line and form—are more evident at this time of year than any other. Without a softening mantle of leaves or deep snow, the stone walls and farm buildings and even the limbs of the far-off trees stand out distinctly. The bones of the gaunt horses in the foreground are equally evident; these animals clearly belong to this lean landscape and play a major role in the photograph. Even their colors harmonize with the setting and are repeated in the dark woods, off-white snow, and streak of dull-yellow tamarack needles that passes through the center of the picture.

Animals add life to the landscape. Here they add depth as well, drawing attention to the foreground and giving a sense of scale to the distant barn. If you block the horses out of the picture, notice how much flatter it becomes. When photographing grazing animals in the landscape, try and pick moments when they are grouped effectively. Horses, cows, and sheep generally look more natural when they are going about their business. Unless you want the interaction between you and them to be obvious in the photograph, try to avoid times when they are staring straight at the camera.

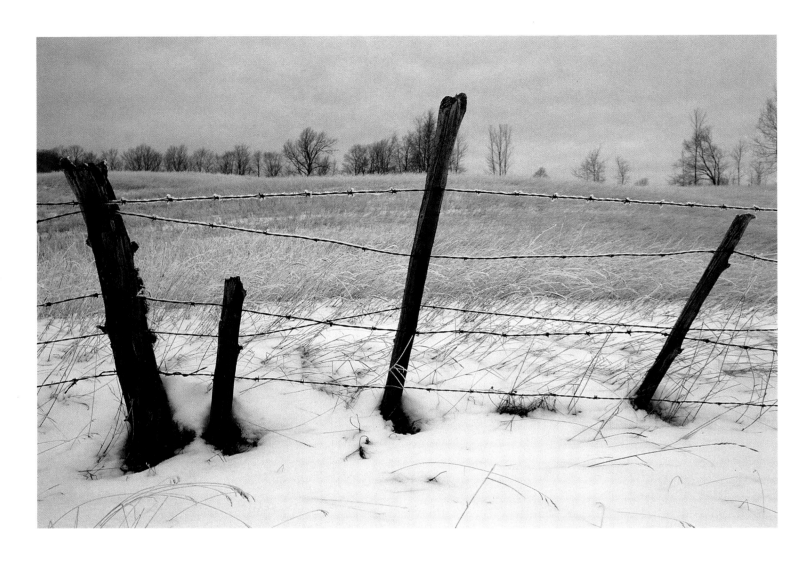

BARBED WIRE, VERMONT

I achieved a feeling of depth in this photograph by getting close to the fence and shooting through it to the far trees with a 28mm wide-angle lens. I was drawn to the lines of the frosted barbed wire, which reminded me of the lines of the musical staff and which matched the minor-key mood of the landscape. When color is restrained, as it is here, landscape subjects need a strong design.

ROAD TO MOSQUITOVILLE, VERMONT

In this photograph I did what you are never supposed to do: put the subject right smack in the center. It was a chance occurrence. I was shooting this foggy landscape, attracted by the maples and scattering of fallen leaves on the untraveled dirt road, when a small figure appeared in the distance, walking from house to barn. There was time for three frames, and then he disappeared.

For me, his tiny, hunched form makes the picture work, and his dead-center placement seems ideal, proof that any so-called rules of composition, including any I might put forward in this book, are to be ignored in the face of a good photograph.

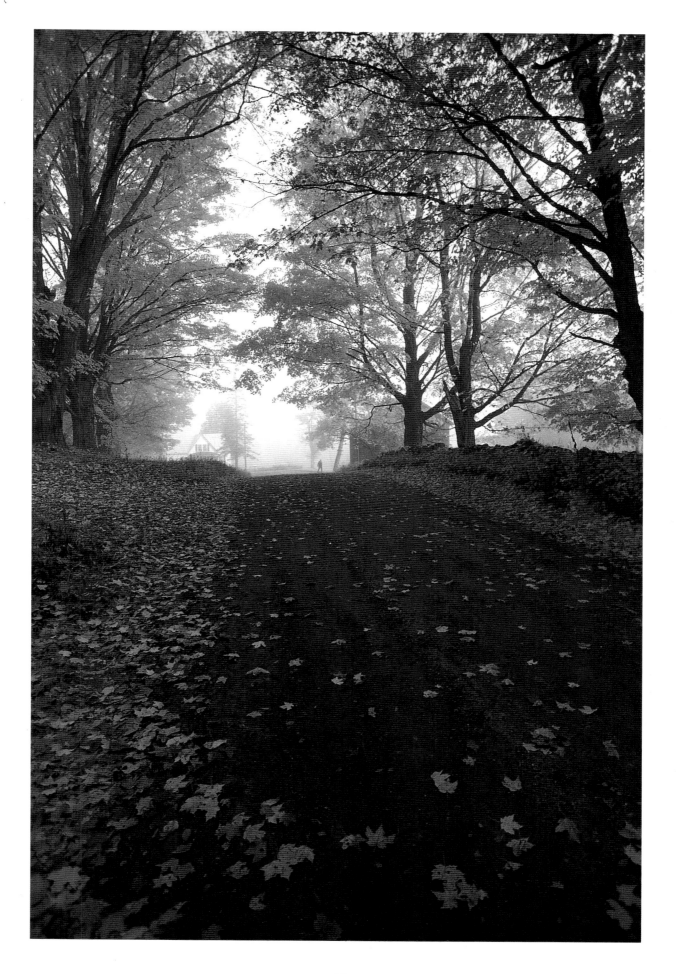

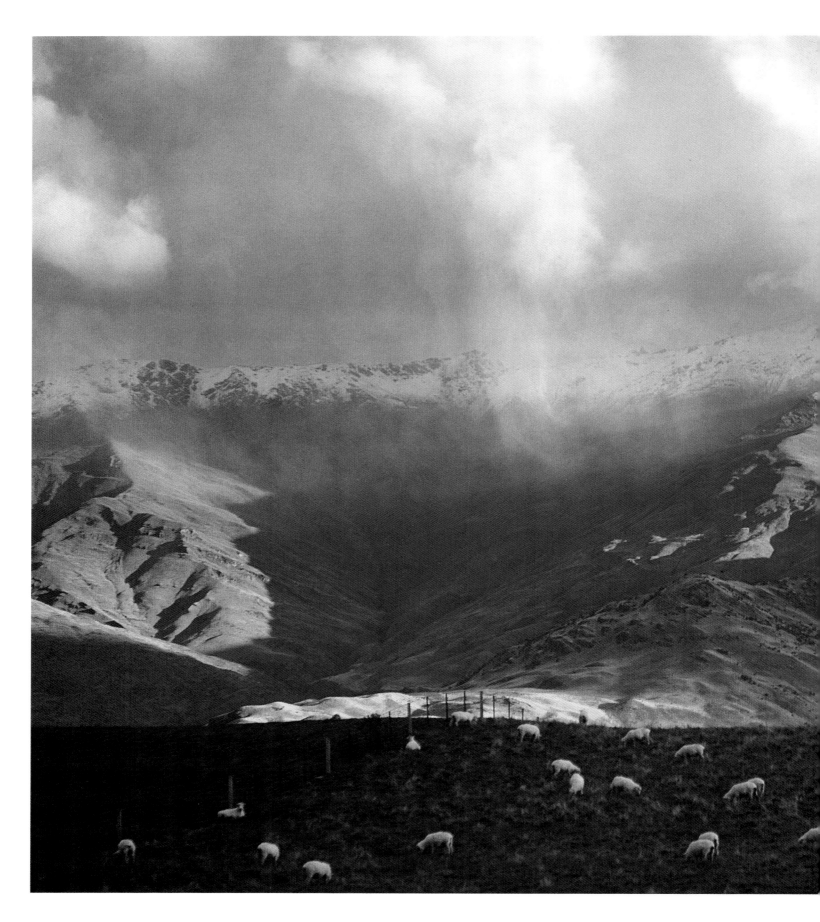

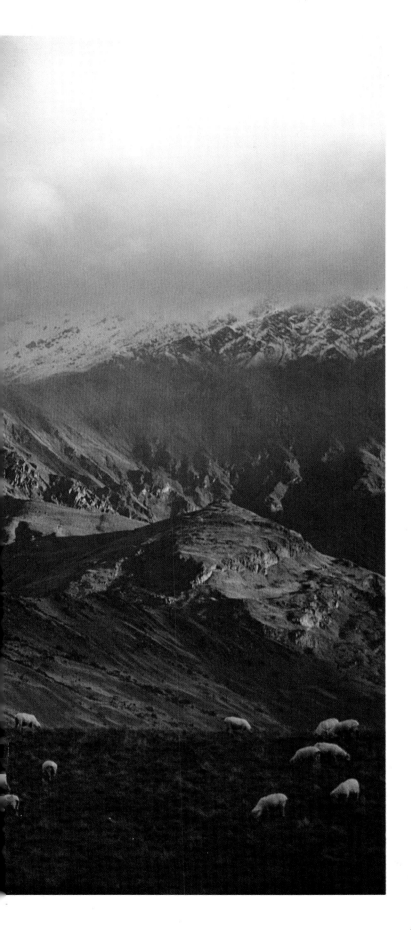

THE REMARKABLES, NEW ZEALAND

The sky is often the dominant element in the landscape, creating drama and excitement that can energize an image. When it starts to *sturm-und-drang* overhead, you should be out looking for possibilities. This picture of a rain squall passing over The Remarkables, a New Zealand mountain group, was taken on a magazine assignment. For six weeks I got to trek through the South Island high country, photographing the farmers and their flocks on the mammoth sheep "stations" there. I even got paid to do it.

At times, the number of sheep was staggering. When we drove thousands of them through narrow mountain passes, they would crowd together into a bobbing sea of wool, and the sheepdogs would run along the backs of the flock and never touch the ground.

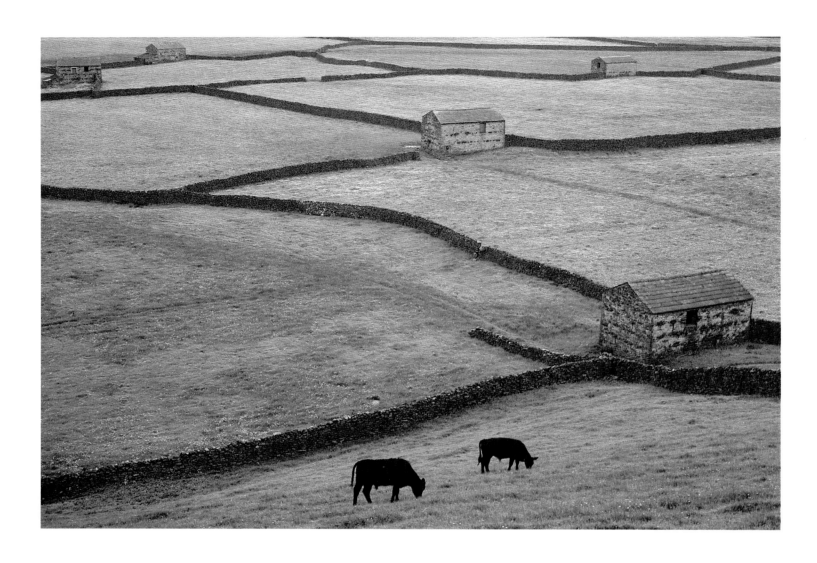

YORKSHIRE WALLS, ENGLAND

The effect of a culture on the landscape fascinates me. The vast net of walls that has been thrown over the countryside in this photograph is doubly impressive once you learn that this ground is stone-free, and every rock here was imported.

The steers make the picture. The first time I stopped they were lying down inconspicuously, so I checked back later and found them on their feet and grazing, as I had hoped they would be. I photographed the resulting pattern of gray walls and black cattle with a 28mm lens.

TREE BRANCHES, JAPAN

In this detail of a landscape near Kyoto, the hand of a different culture is felt. The meticulously pruned pines and contorted cherry trees have been raised with a Japanese discipline. The compositions of both photographs on these two pages are strongly linear, but they create opposite effects. The gently undulating Yorkshire walls connote rest and calm, while the forceful upright thrust of the Japanese pines emphasizes action and movement. I used a 105mm telephoto lens for these trees to heighten the dynamic character of their growth.

ISLAND AND SCHOONER, WEST INDIES

I wish I could say this photograph was the result of an arduous climb up a mountainous island that took most of a day and yielded this dramatic view as a reward for my strenuous effort, but that would be a lie. In fact, I was enjoying an elegant meal at a friend's house on top of Saint Barthélemy, a French island in the West Indies. The camera and tripod were set up on the terrace a few steps from the table, and as the sky grew more brazen over the neighboring island of Saba, I would take a few bites of *langouste* and a sip of wine, walk over to the camera, shoot a few frames, and then return to the table without losing the flow of the conversation.

This is without doubt the most effortless picture I have taken. Opening the wine was more difficult. I would like to add in my defense, however, that gifts to the photographer like this make up for all the mountains (hills, really) that I have climbed with no pictures to show for the ascent. Such is the nature of photography. You work and you work with middling results, and then something wonderful is handed to you. Always take a camera with you so you can receive these gifts when they are offered.

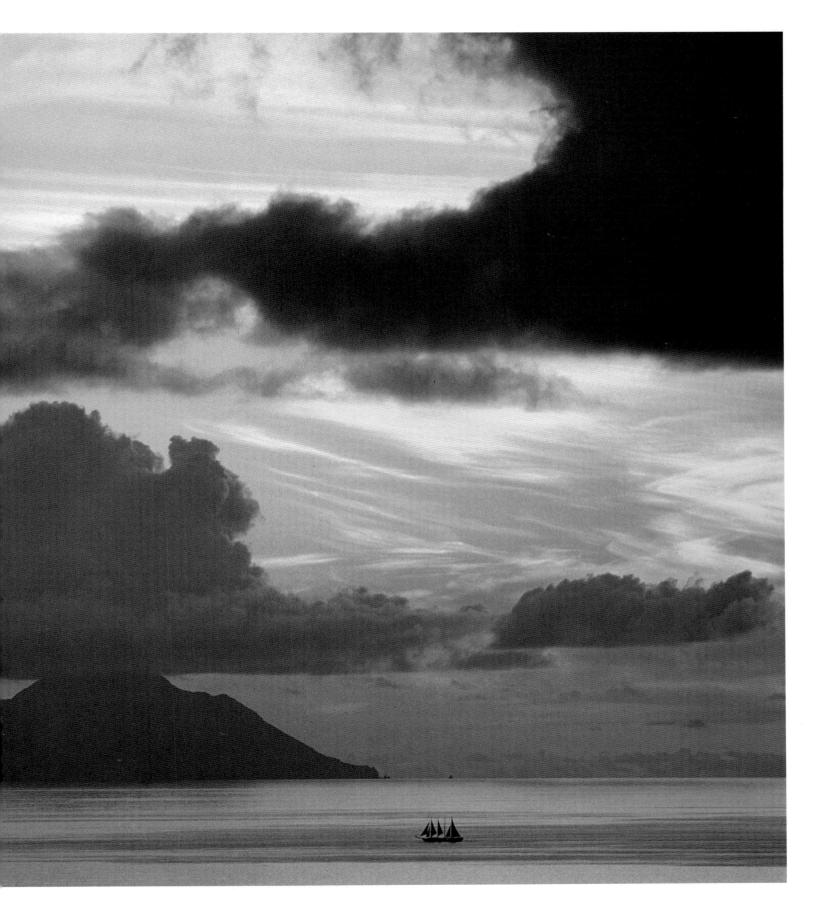

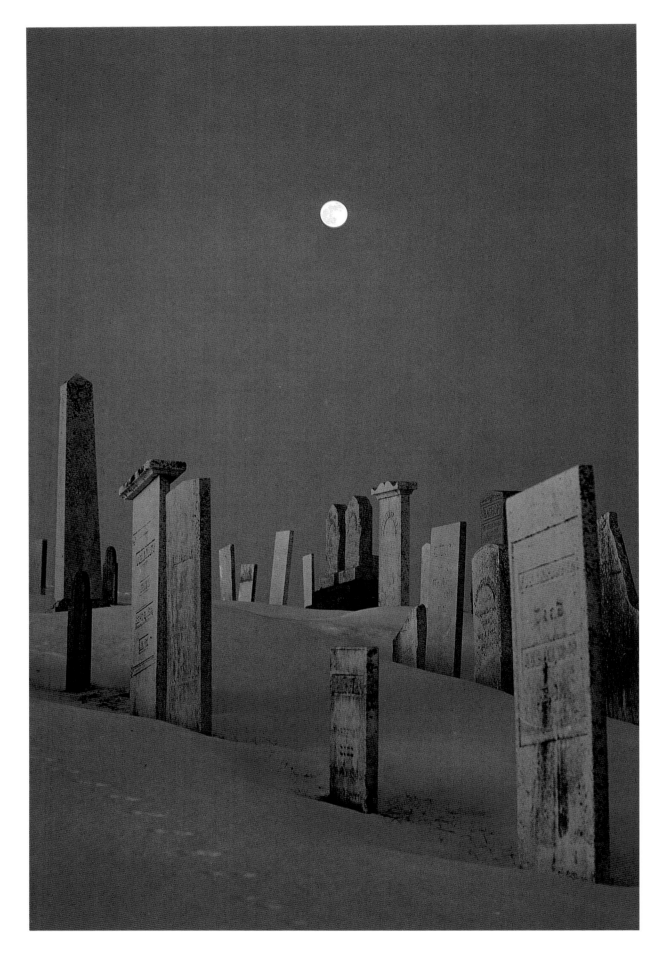

Sun and Moon

There must be some druid blood in my veins, because the rising and setting of the sun and moon never fail to move me. There is a hushed and expectant feeling in the air during these moments, and I feel a clear sense of elemental forces at work. I still get goose bumps when—as I wait with camera set on tripod and pointing due east over a darkened landscape—the silver disc of the full moon first edges into view. Being a photographer allows me to practice this celestial worship without being considered entirely crazy.

Photographs of the sun and moon are best taken at the beginning and end of the day. Then the brilliance of these bodies is most tempered by the Earth's atmosphere, and their close proximity to the horizon creates tension and excitement. To my mind, a vermilion sun just lifting free from the rim of the ocean is more expressive than one that shines some distance above it, and an icy white moon grows more haunting when it hangs low in the western sky and begins to set behind a Stonehenge of gravestones.

The full moon's size can be startling when it first appears. Perhaps you are driving around a curve in the road or happen to glance out of the kitchen window, and there it is, looking huge and tinged with yellow. Later, as you check its path high overhead, it seems to have shrunk. It appears smaller in this vast expanse of black sky because it has no point of reference. Earlier, however, its juxtaposition with familiar and nearby objects, as it first rises above the outline of a hillside or sets behind the cupola on a neighbor's barn, gives a sense of increased size. Photographs that capture the moon as it hangs near the horizon and flirts with elements in the landscape take advantage of this illusion.

Often photographers try to convey a sense of the sun's or moon's grandeur by using a long telephoto lens and filling the frame with a giant glowing ball looming above the skyline. While I wouldn't discourage anyone from trying his own version of this, it is an approach that distorts reality, and more original ways exist to indicate the power and beauty of these subjects. Ansel Adams's best-known photograph, *Moonrise, Hernandez, New Mexico*, shows a nearly full moon suspended over a simple but eloquent Southwestern landscape— an adobe village and church, a sparse cemetery, and distant bands of mountain and cloud.

MOON AND GRAVEYARD, VERMONT

The setting moon edged toward a hilltop cemetery as dawn light colored the gravestones. This was the moment of truth—about 6:30 A.M. An overall impression of darkness prevailed, but there was adequate light for foreground illumination. A little earlier and the graveyard would have been too dark, a little later and the moon would have been too faint.

I used a 105mm lens at f/22, but the nearest stone was still slightly out of focus. Because maximum depth of field was inadequate to give absolute definition to every element in the frame, I had to choose between the moon and the gravestone, and I felt the moon depended on razor sharpness for the most dramatic effect.

The moon is realistically scaled and takes up only a tiny portion of the picture, but because of the masterful evocation of mood, its diminutive presence has profound impact.

When you are photographing the sun or moon, remember that they are potent symbols, and to command our attention, they don't have to dominate the image physically. The rising sun in the Cumberland Island photograph on pages 110–111 is just a red dot on the ocean, considerably smaller than the fragment of sand dollar seen in the lower left foreground. But because of its intrinsic power, its placement at the center of the horizon, and the intensity and warmth of its color in contrast to the soft purple–black of the beach, it is the prevailing element in the image. In the photograph of the swan and sunset on page 104, I left the sun out of the picture altogether, but it is still an implied part of the composition, unmistakably suggested by the shimmering band of its reflection.

When it is not rising or setting, the sun is usually too bright to be shown directly in a photograph, but if it is thinly veiled by clouds or fog, it can be incorporated into the picture, as it is on pages 106–107. A ferocious wind filled the air with blowing snow and dimmed the midday sun when I photographed the farmer and his dogs making the trek from house to barn. This picture gains both luminosity and irony by the inclusion of a cold and cheerless sun.

If the sun is too blinding to be photographed, its reflection may not be. Reflected images of the sun, or any other object for that matter, are always more subdued than the original. When the sun is overly glaring, it can be mirrored in a puddle or a tidal pool or in a pond, like the one covered with water lilies in the photograph on page 105.

The brilliance of the full moon also has to be held in check to produce successful pictures. In an ideal exposure, the moon is shining brightly but still has some detail (what we call "the man in the moon"); and whatever lies below is darkened, but retains perceptible features. In other words, the moon should look radiant but not overexposed, and the landscape should look dimmed but not underexposed. A delicate balance of light has to prevail.

Early twilight is the best time to find the necessary harmony of light, and it is possible to take photographs of a luminous moon with its face clearly visible, shining over a darkened but easily discernible countryside. Ansel Adams's *Moonrise* gives the feeling of nightfall but was actually taken at four o'clock in the afternoon.

This ideal combination of moon brightness and land darkness should occur an evening or two before the full moon. On this evening, the moon rises early enough to reach an optimum level above the horizon just as the light from the setting sun is beginning to fade. It takes experience to judge this moment of balance accurately. If you wait until it is too dark, exposures long enough to reveal detail in the landscape will burn out the moon, and it will look like a white hole in the photograph.

Effective photographs can also be taken at dawn as the moon is setting, when the schedule is reversed. The morning or two following the night of the full moon should be the most favorable.

Photographing the crescent moon requires a balance of light as well, but because this moon is only a curved slice of white, with no real detail, overexposure is less of a worry. More problematic is the crescent moon's elusive nature. For most of its travels across the sky, it keeps close company with the sun and is virtually invisible. For several mornings before it

wanes completely, however, its narrow sliver can be seen rising in the eastern sky before the sun makes its flamboyant appearance. A similar opportunity occurs in reverse a few evenings later, when the waxing crescent appears in the western sky lagging behind the setting sun. The best moments for photography in either case occur when the sun is well below the horizon and only a band of light colors the sky's edge. Enough darkness must be present to make the moon's crescent stand out. This timing leaves little light to illuminate your surroundings, and you need to rely on outline and profile when choosing compositions. The strong, graphic shapes of the lighthouse and picket fence in the photograph on page 109 are easily recognizable, even in semidarkness, and provide bold silhouettes that contrast effectively with the delicacy of the waning crescent moon.

Luck plays a part in photographing the sun or moon, as it does in all photography, and while you are out searching for pictures some still July dawn, a blood-red rising sun or lemon-yellow setting moon may providentially appear, an unexpected but welcome guest. To improve my odds of finding such a promising shot, I always travel with a compass and notebook, to keep track of any location that bears revisiting for a potential moonrise or sunset. The compass gives a good indication of where these events will occur, but keep in mind that the exact points on the horizon where the sun and moon rise and set vary somewhat from season to season. During the winter solstice, the sun appears a little south of due east, but by summer its risings have shifted more to the north. Sunsets in the west vary accordingly. In contrast to the sun, the full moon rises to the north in the winter and the south in the summer.

Another invaluable tool for increasing your chances of picking the right time to photograph is an almanac. Every fall, I purchase a copy of *The Old Farmer's Almanac*, replete with cover picture of idyllic country scenes and Benjamin Franklin's likeness. In addition to providing useful information about each day of the upcoming year, like "propitious day for birth of women," or "Charles II first tasted cranberries, 1667," it features complete astronomical tables, which give exact dates and times of the sun's and moon's various comings, goings, and phases.

When photographing these events, I like to get to a suitable location early, for "a good seat." I need time to reflect and set up. Pictures like the one of the full moon and graveyard, or of the lighthouse and waning moon, require many minutes to allow me to study camera angles and vantage points. I must always make a few final adjustments, especially for pictures taken right at sunrise and moonrise, shifting equipment when the glow in the east reveals to me the exact spot where the sun or moon will emerge.

There is one other reason I like to be in an opportune spot early: as with most of life's pleasures, anticipation is half the fun of photography. I find something eminently satisfying and reassuring about waiting for a sun or moon to appear. I relish the growing light, watching sun or moon rise fire-red or silver-white over a fitting horizon, center stage and right on cue, majestic and immutable. *Click!*

LAC LEMAN, SWITZERLAND

The hours of sunrise and sunset do magical things to water. In this instance the lake had an iridescent sheen, and its rippled surface looked freshly combed. I waited until the swan moved to a spot where it balanced the column of shimmering light caused by the setting sun. The sun itself was dim enough to include, but I left it out to make the image less conventional.

GARDEN POOL, WALES

A reflected sun adds ambiguity to this photograph. We are looking up and down at once. I moved my camera and tripod until the sun's reflected image floated in the space between the lilypads. By slightly underexposing, I held its brightness to an appropriate level and darkened the surrounding clouds. The result adds further visual mystery. What is actually the sun's reflection looks startlingly like the full moon shining through a cloud-filled darkness.

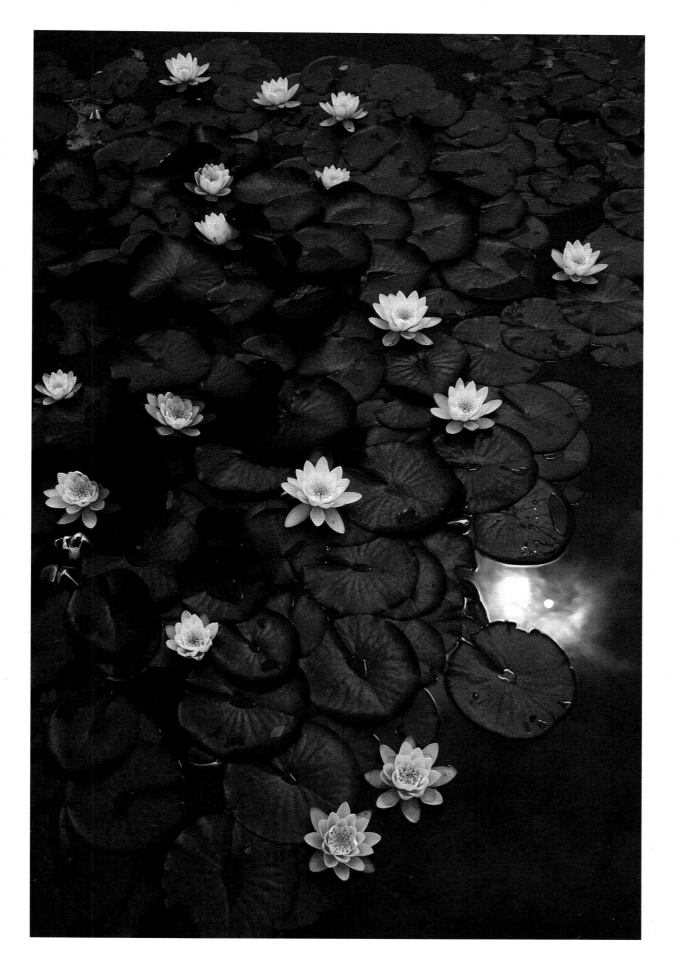

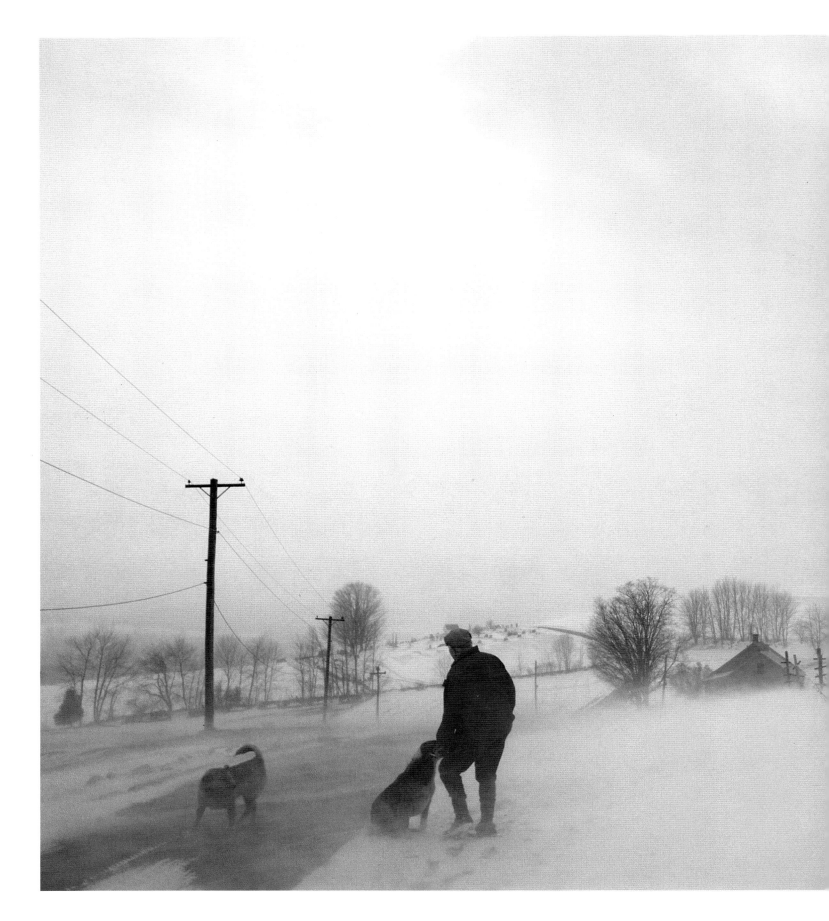

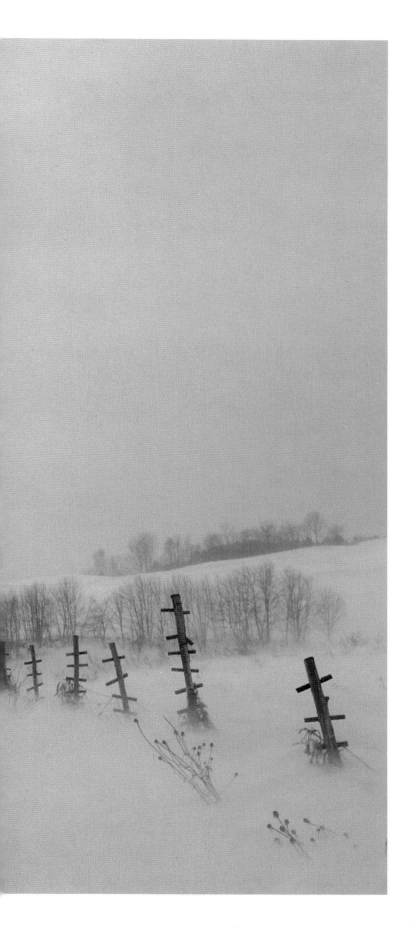

DRIVING SNOW, VERMONT

I took this photograph as swirling clouds passed over the sun, cutting its glare but leaving a distinct impression of its outline. It is an ironic presence, giving a definite play of light to the sky, but no feeling of warmth. The scene seems much colder for the sun's wan attendance.

The farmer was making his way from the house below to a neighboring barn, where a cow was due to calve. The wind was strong enough to lean against, and the hard-driven crystals of snow stung the skin. The farmer had to turn his face away from the wind and shoulder his way into the gusts. The gale was at my back and my body shielded the camera, otherwise any photography would have been impossible.

You have to love winter to live here, and this was mid-April! Inside the barn, the warmth of sixty Jersey cows and a newborn heifer calf greeted us.

Notice how the lines of telephone poles and garden stakes march into the image from either side . . . just a bit of luck.

MOONRISE, VERMONT

January's "wolf" moon caught me by surprise as I returned home one evening. It was nearly dark, and the one-second shutter speed required for proper exposure of the underlying farmscape meant some overexposure of the full moon and the loss of lunar detail. Fortunately, a stray cloud softened its outline and also magnified its golden luster. Remember that the moon is a moving object, and exposures much longer than a second will show some blurring.

PEMAQUID LIGHT, MAINE

This direct picture of a lighthouse at dawn required a complex equilibrium of light. I arrived early, at 4:00 A.M., and waited until the shining sliver of moon, the brightening sky, and the flashing beacon were synchronized. Within minutes of this exposure, a brilliant sunrise completely obscured the moon's thin crescent, and the lighthouse ceased its flashing. I packed up my equipment and decided to try my luck at Muscongus Bay's other renowned landmark—Moody's Diner.

CUMBERLAND ISLAND, GEORGIA

Here my camera recorded a tiny but potent sun as it first cleared the horizon off the coast of Georgia. Only two colors, purple and pink, were evident, but the range of hues and the ways the sand and water reflected them were special. I never thought white sand could turn the color of a ripe plum until I took this photograph.

The composition relies on bands of interest: the uppermost stripe of luminous sky, the narrow line of lapping waves, the pinstripe of bright reflection, and the broad curve of the tidal stream in the foreground. Such a dominant linear arrangement causes our eyes to sweep back and forth across the image, only to pause at the punctuation marks: the sun and the fragment of sand dollar in the lower left corner.

This piece of sand dollar may seem insignificant, but because it is included in the extreme foreground, the scale and closeness of the stream's edge are clearly established, and the feeling of depth in the photograph is enhanced. I used a 28mm lens and positioned my camera as low as the tripod allowed, centering the sun on the horizon to heighten its effect.

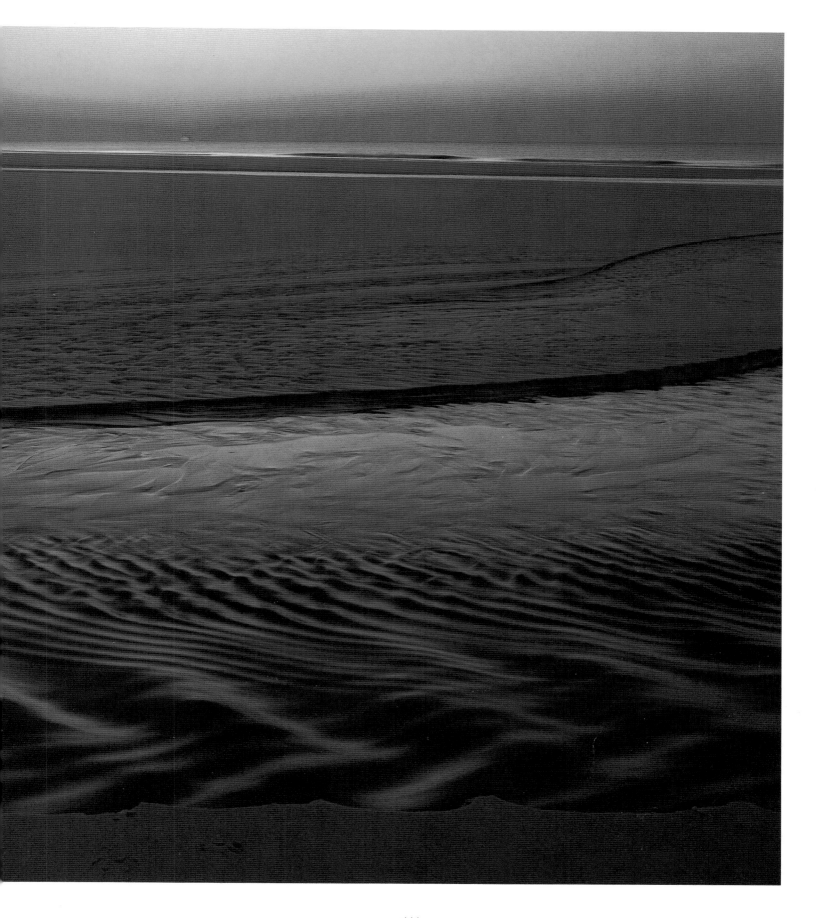

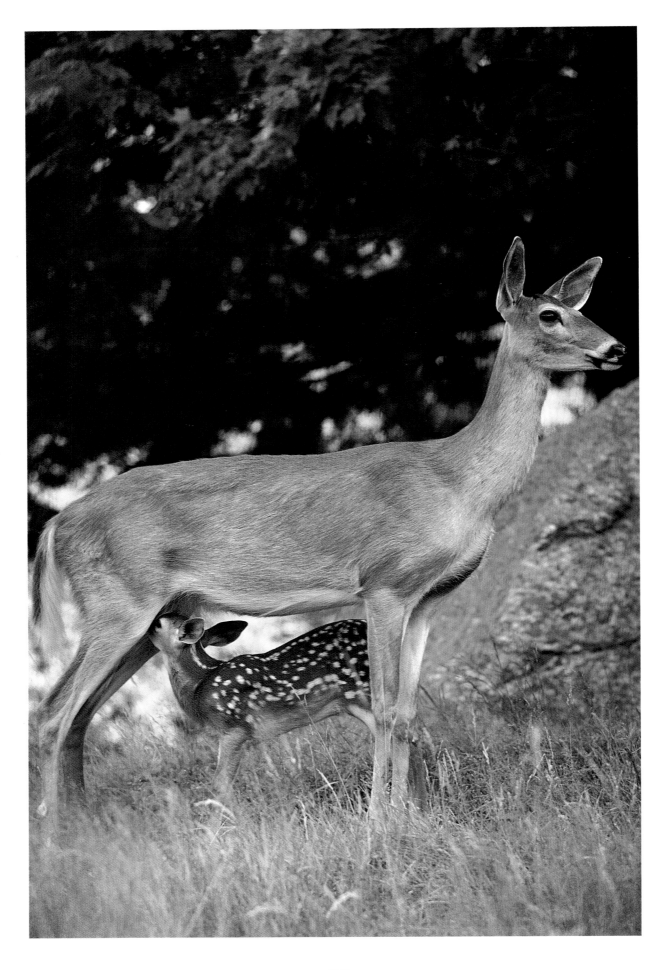

Nature

Every nature photographer knows well the irony of time. You are either waiting interminably for the right instant or rushing frantically so that you don't miss it. And you may spend ten hours waiting to have only a few seconds of actual picture-taking. Waiting is a big part of nature photography—waiting for the right light, waiting for the wind to die down, waiting for the doe to return to its fawn hidden in the tall grass. You need to cultivate patience as much as a good eye. When photographing nature, I have found that the most valuable piece of equipment to bring along is an entertaining book.

But when the moment arrives, especially when you're photographing wildlife, speed—and fast reflexes—are required. Some are born with the gift, and others, like myself, can only try their best, a fact I realized while watching Art Wolfe, a master wildlife photographer, at work. He, Larry West, and myself, sometime contributors to *Audubon* magazine, had been asked to teach a course in nature photography at an Audubon sanctuary on Hog Island, a pristine island off the coast of Maine. Early one morning we headed an expedition to a large heron rookery. As we approached, we could hear the croaking cries of the herons and smell the attendant aroma, which was—how-you-say?—invigorating. Art led the way with a blunderbuss of a lens, a 180mm-600mm zoom. (You could eat a meal off the lens cap.) The woods was a nearly impenetrable tangle of spruce, and the going was slow. Suddenly we broke into a clearing where the droppings of generations of herons had killed all vegetation. Each skeletal tree was crowned with a giant stick nest, sprouting one or two long-necked young herons. The adults were wheeling over the nests, feeding their offspring and looking somewhat concerned, though not alarmed, at our appearance. In a blaze of speed, Art's camera was on its tripod, and the high-pitched whine of his motor-drive joined the cacophony of the birds. Larry wasn't far behind. Art had finished two entire rolls, and Larry one, while I was still struggling with my tripod.

Obviously, if you want to specialize in wildlife photography, where glimpses of shy and often distant subjects are fleeting at best, long lenses and motor-drives make sense. Quick-release systems are also available; these allow you to snap the camera on and off of the tripod without losing valuable seconds fumbling with a screw.

While I freely confess to being an infrequent wildlife photographer, I have done

DOE AND FAWN, NEW HAMPSHIRE

Hours of waiting paid off when this doe returned to nurse her fawn. Every June, local farmers call to let me know of young deer they have found hidden at the edges of their fields. Putting the word out that you are interested in finding wildlife subjects produces many good leads. A 200mm telephoto lens let me shoot at a safe distance, where I could pull in precise details, like the mother's finely edged ears and the fawn's dappled coat, without alarming the deer.

enough over the years to pick up some rudimentary knowledge. The best piece of advice I can give may be insultingly obvious, but it is surprising how many overlook it. Simply put, it is *Go where the pictures are.* It's a little foolish to decide one morning to photograph a fawn and blithely head off into the woods with your camera. This is an exercise in certain futility. Instead, do some scouting to improve your odds. Talk to neighbors, game wardens, foresters, and loggers who might know where deer have been browsing, or where they are likely to yard up in the winter. On several occasions, a farmer has called me in June when he has come across a fawn hidden at the edge of a field that he was mowing. Fawns usually stay put unless disturbed, and I have often been able to photograph one waiting for its mother, or better yet, with patience, I have captured the moment when she returned.

While most spectacular wildlife photographs are taken in preserves and parks where wild animals are common and accustomed to humans, don't overlook what is close at hand and familiar. A nearby vacant lot or unmown field can be a rich hunting ground for small game—spiders weaving their frail architecture, for instance, or a monarch butterfly emerging from its jade-colored chrysalis. A backyard birdfeeder provides winter pictures of cardinals or evening grosbeaks waiting on a branch for their meal, puffed up against the cold. Surprisingly, the best opportunities for photographing wildlife can occur in decidedly unwild places. When I photographed the snowy egret on page 118 feeding at the edge of a Florida beach, I could hear the not too distant call of a transistor radio, and in the case of the Canada geese on pages 116-117, I could feel the nearby rumble of stampeding trucks on the Long Island Expressway. By carefully selecting my background, I was even successful in getting some wild-looking shots of black bears trashing a northern Minnesota dump.

Once you have spotted a worthy subject, give some thought to the composition of the photograph. Do not automatically put the creature smack in the center of the frame. When you finally catch sight of something as rare as a fawn or a bear, your excitement may be such that you want to make sure it is "captured," so you place it squarely in the middle of the picture. This approach leaves little space to include additional elements that might add interest or improve the composition. Consider balancing your wildlife subject with something else in the landscape, or think about creating some tension by placing the subject closer to one edge of the frame. (Bears provide a little tension all on their own.) If the animal or bird is in motion, give it some space in the photograph to "move." Or if the subject is at rest, include some telling part of its environment to make a more complete picture.

While wildlife has been a part-time subject for me, the area of nature photography that has constantly held my interest is the study of the quiet corners and intimate details of the natural world. The Vermont birch woods shrouded in fog on page 120 or the spent petals of dogwood blossoms brightening a Georgia forest floor on page 125 are examples of this fascination. I purchased my first camera after seeing Eliot Porter's book *In Wildness* In it, Porter paired quotes from Henry David Thoreau's writings with crystal-clear, contemplative photographs of untouched New England—not broad vistas, but human-scaled views of forest, stream, and shoreline. This book had a lasting effect on me, for it movingly illustrated the power of the camera to convey the magic and spirit of wildness.

Photography, with its capacity for recording the finest physical detail and slightest

nuance of tone, is an ideal medium for capturing the complexity of the natural environment. The surprising juxtapositions, the infinite variety of patterns, the unexpected visual rhymes, the combinations and interactions of colors that nature produces with such offhand perfection are all particularly amenable to lens and film.

Being in an unspoiled place with a camera is an excuse to spend unhurried hours just looking. Give me a soft, overcast day with just a whisper of wind and set me loose next to a rockbound New Hampshire stream in October when the falling leaves litter the ground like giant pastel snowflakes. Or put me at the edge of a cove on the coast of Maine where I can putter around in the tidal debris of bleached driftwood, chalk-blue mussel shells, wild rose petals, and the black tangle of dried seaweed. In such circumstances I am in photography heaven!

If you find yourself in a similar paradise, there is one small temptation that will arise as surely as blackflies on the first warm evening in May. While you are focusing on some seductive detail, you will inevitably want to improve on nature's design. You will think that by turning that odd shell over or by ever so slightly rearranging a few fallen leaves you will make things look better. Don't. Nature is never *too* tidy. Something always looks vaguely wrong and faintly contrived when you mess with it. I know because I've tried it often enough myself. Nature photography is the art of seeing and finding, not arranging.

There are times, however, when judicious cleaning up is necessary. Unless you are making a statement about environmental degradation, any stray can or food wrapper adds an unwelcome element in the photograph. Litter should be picked up whether you're photographing or not. Another bit of editing may have to be done when a tall weed stalk comes between lens and subject. Responsible nature photographers carry some twine in their camera bag for tying back obstreperous branches that interfere with the view, rather than stripping limbs from the tree.

Like all photographers, I suffer from bouts of photographer's block. Nature is the muse I most often turn to when creative energy starts to fade. To motivate myself and to sharpen my eye, I have gotten in the habit of giving myself seasonal nature assignments. I choose a single subject—one fall it was the reflections of foliage in water, more recently, the structural beauty of ferns—and try to think of every possible approach and composition. How many ways can I work a fern's elegant shape into a picture? The photograph of a rattlesnake fern on page 124 is a result of this assignment. The image doesn't show the actual fern, only its purple-blue ghost mirrored in a shallow pool, but the startling color of this shadow draws attention to the simple symmetry of its form.

I highly recommend nature as a source of inspiration. Choose a tempting subject—something special from the menu. Steal some time from the obligations and bits of nonsense that crowd each day. Pack a camera and lots of film, return to a favorite haunt, and give your imagination free rein. It will be time well spent.

GEESE AND REFLECTIONS, LONG ISLAND

These Canada geese floating on a stained-glass pond were photographed for an *Audubon* magazine cover. After the issue appeared, the editors received several irate letters from readers complaining of trick photography. One subscriber even accused me of laying colored cellophane on top of the water (with holes for the geese?).

In fact, the surface of the pond was in the shade, but reflected brilliant fall foliage that was in full sunlight. As the geese swam back and forth the water became a kaleidoscope of colors. It was a dazzling display, and a good argument for not always following my advice—this picture was taken at noon on a brilliantly clear, "too-damn-nice" day.

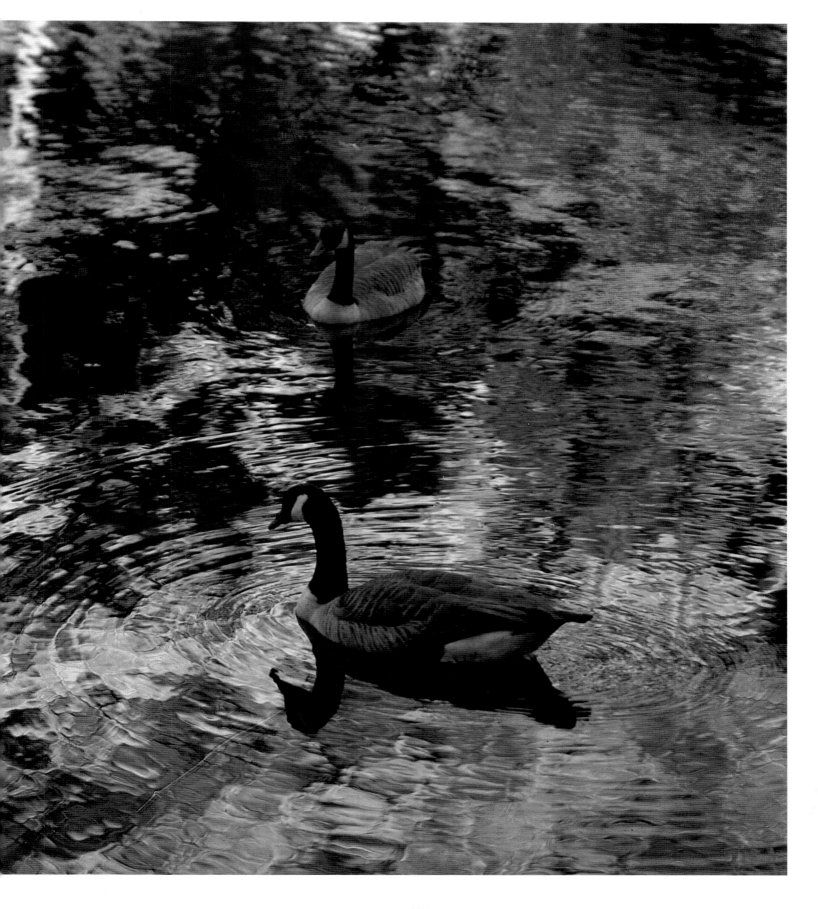

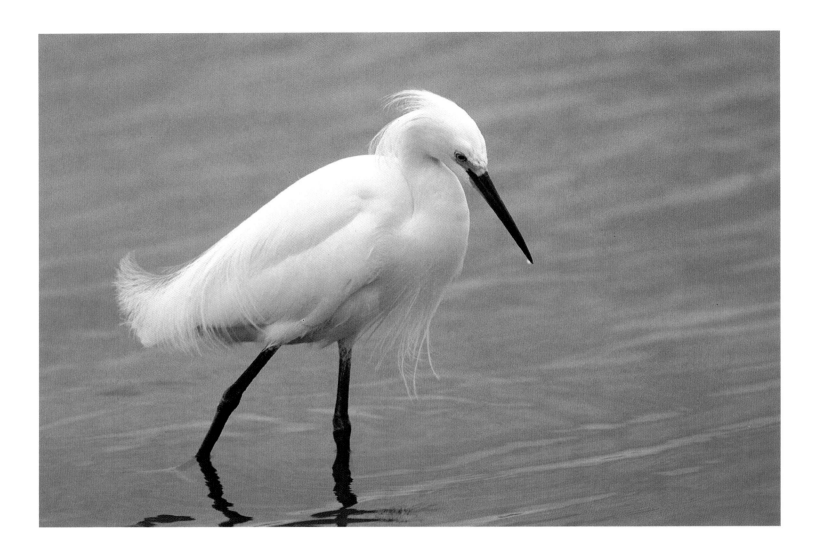

SNOWY EGRET, FLORIDA

This photograph and the one on the opposite page were taken with the same 200mm lens, but show different approaches to wildlife photography. Here the aim was to make a portrait of the wading bird and concentrate on its characteristics—the long black legs and stiletto beak, flowing plumes and attentive yellow eye. The droplet of water on the end of the beak is a touch that adds a little personality to this chaste specimen. I waited until the background was clean and simply patterned, and placed the egret a little left of center to make the photograph less static and leave the bird space to wade into. To give some idea of normal odds in this kind of work, I might note that I took seventy-two shots to get this image and one or two others that I was pleased with.

AMERICAN EGRETS, FLORIDA

I waited three years to get this picture. On my first trip to this Sanibel Island sanctuary, clouds obscured the moon. The second year I watched as a flock of roseate spoonbills circled and landed in the moonlight only to be frightened off by my tripod, which squeaked as I adjusted it. (I have now learned to test all equipment for noise before photographing wild subjects.) The third year, with experience on my side, I knew where to stand, exactly where the moon would rise, and which tripod to bring.

In this image I wanted to say more about the world these birds inhabit than about the birds themselves, though their characteristic pose makes identification easy. I chose a composition with the horizon placed low to stress the feeling of space, and I waited until the moon had climbed to a point where it would balance the birds at the bottom of the frame.

BIRCHES, VERMONT

Birches are poor candidates for the wood stove but excellent subjects for the camera, especially emerging from an overnight blanket of fog. This stand grows a short distance from my home, and though I've photographed it dozens of times, I can't drive by without stopping to see if there is anything I've missed. This kind of subject bears frequent exploration. I used a 28mm wide-angle lens for this study of the rhythm of the birches' forms.

LUNA MOTH, MAINE

This moth remained motionless, clinging to a spruce trunk for two hours, giving me plenty of time to experiment and vary the picture. Early morning is considered the best time for photographing insects. At this hour there is good light, little wind, and, frequently, dew. More important, insects are sluggish in the cool of the morning and therefore less camera-shy. Photographers who specialize in insects as subjects have been known to keep a stable of six-legged models in their refrigerators for convenience and tractability, but importing creatures always struck me as a highly suspect technique in "wildlife" photography.

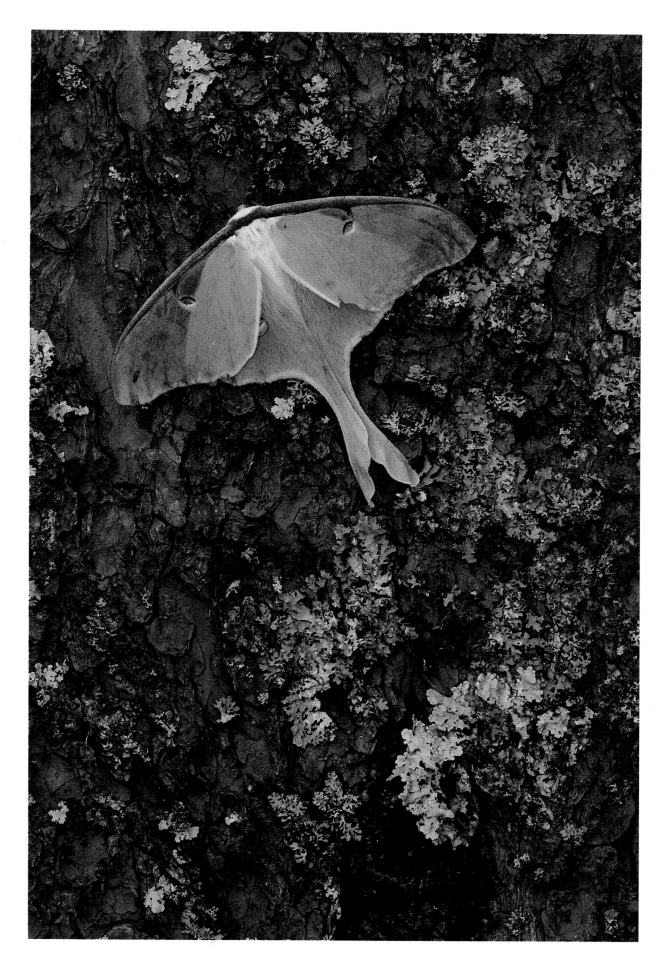

ACADIA COASTLINE, MAINE

A 28mm wide-angle lens took in the full curve of this rocky inlet, as well as the swirling surf below my feet. The way moving water looks in a photograph depends on the length of exposure. Slow speeds of ⅟₁₅th of a second and longer increasingly blur movement until an unearthly, foglike effect is achieved in the two-to-four-second range. Shutter speeds of ⅟₂₅₀th of a second or faster freeze waves into boiling explosions of foam.

The mood of a seascape can also be affected by the choice of shutter speed. This cove would appear less stormy with a long exposure; the breaking waves would blend into an indistinct white mist, and a feeling of ghostly calm would prevail. For this photograph I wanted enough blurring to indicate movement, but I didn't want to lose the choppy texture of the ocean, so I settled on ⅟₁₅th of a second.

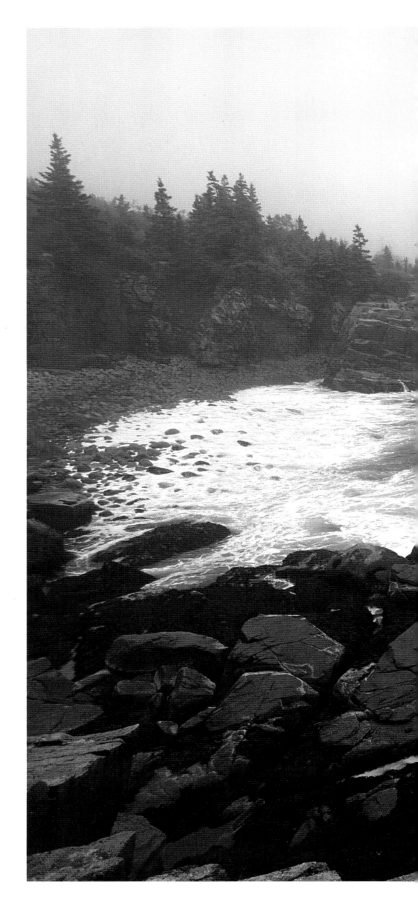

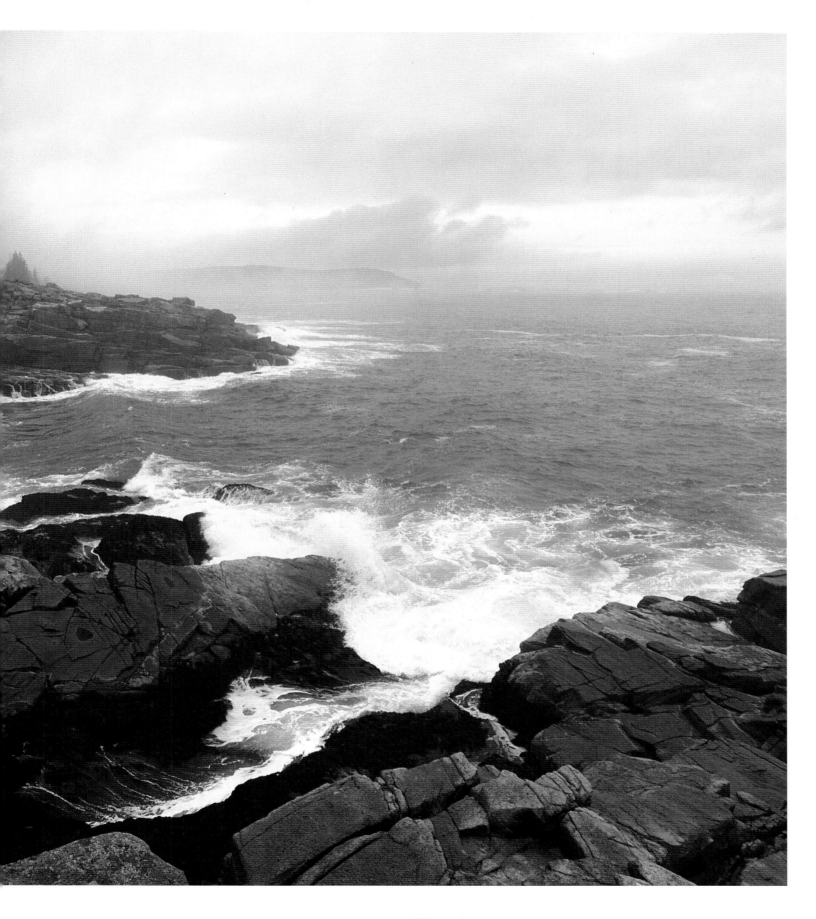

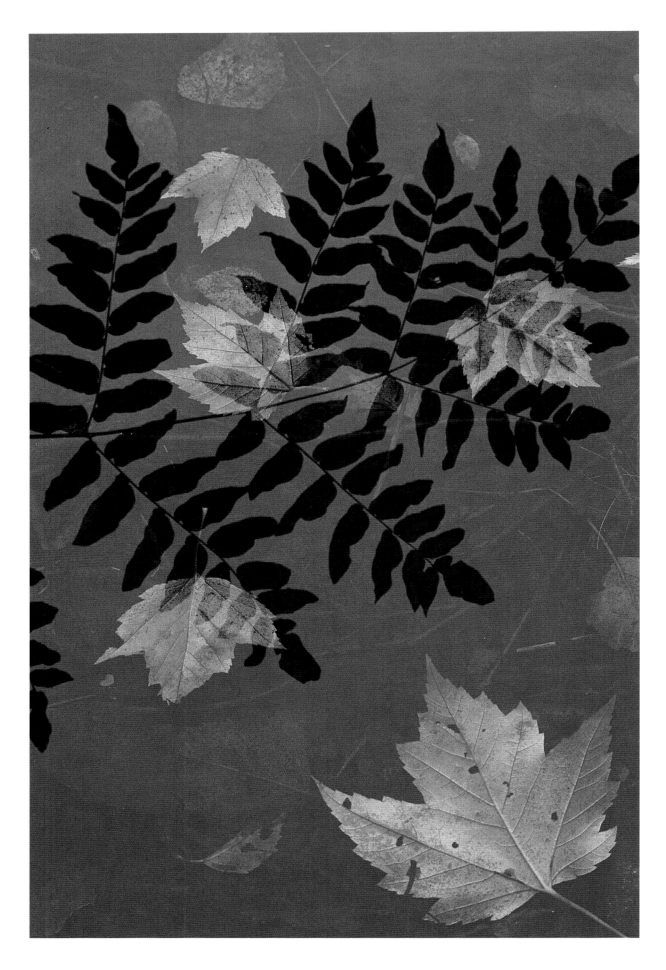

RATTLESNAKE FERN, NEW HAMPSHIRE

This photograph of a shallow pond mirroring an overhanging fern is colored by reflected light from the sky. I waited for a stray cloud to provide the shade that I wanted for even tones and reduced glare on the water's surface. The rest of the sky remained a brilliant blue, however, which tinged the water, the submerged leaves, and the fern's reflection, creating a surreal mood. Using a 105mm lens, I shot almost straight down, being careful to place the tripod so its reflection didn't enter the picture.

DOGWOOD PETALS, GEORGIA

The pine woods of Georgia were filled with native dogwood at peak bloom, which I duly recorded, but I preferred the fallen blossoms as a subject—they had the sting of mortality. For forest-floor detail work I often use a 105mm lens, as I did here, because it provides a comfortable working distance between photographer and subject—four to five feet. It also has a slight flattening effect that adds to any feeling of design that may be inherent in the subject.

SNOWY OWL, VERMONT

This winter denizen was photographed in a nature preserve after a fresh snowfall. I had tried to get a picture of the owl on several earlier occasions without success, but this morning the fluffy quality of the new snow was perfect, and the bird was in an ideal spot. I was looking for a white-on-white picture, with only the black feather-tips, hooked beak, and mesmerizing yellow eyes separating the owl from its pristine surroundings. Note that the bird isn't centered; by giving the snow equal space, I hoped to show the uncanny similarity between the texture of the snow and that of the owl's feathers.

This is a good example of a subject that requires overexposure. By bracketing one and two stops over the designated f-stop, I made sure the owl and snow would look white and not "middle gray."

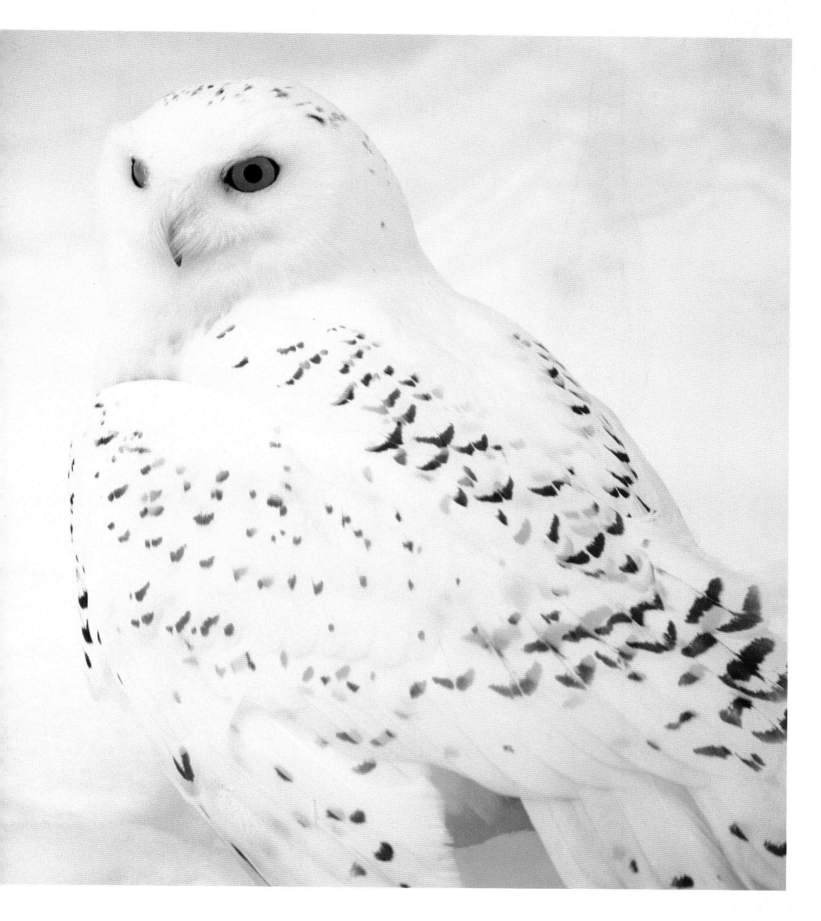

Sense of Place

The first time I saw Vermont's Northeast Kingdom I felt it was home. There was a quality to the region's landscape and its native-born inhabitants that set the "Kingdom" apart from the rest of New England, indeed from the rest of Vermont. The place tugged at my affections. I sensed this feeling was somehow mutual, insofar as a landscape can show favor. I have often felt while photographing this area that I have been led to just the right spot at just the right moment, and have been granted privileged glimpses of the flinty, hardscrabble, yet beautiful character of the region.

I was allowed to see a world, now largely gone, of wood-burning cookstoves and steaming canning jars, wash hung out to dry, loose cotton dresses and barn boots, pie crust made with lard, and cut hay lying in fragrant windrows under the flat heat of a July noon. It was a world of hard work with little to show for it except fierce pride.

I felt the privilege of my position the first time I climbed the steep pasture behind John Somers's farm, though I didn't know yet whose place it was, and caught sight of the land spread below, whitened with October's frost and gleaming eerily in the predawn light. Rolling hills descended to a pool of fog that marked the Connecticut River, and then the hills climbed again to Mount Washington, a pale blue point fifty miles to the east. The Somers farm lay just below me, straddling a dirt road. A few lights were on in the house and in the barn, woodsmoke rose in a lazy column from the chimney, and a handful of grazing cows cast a net of trails in the frost as they moved across the hillside toward the barn where the rest of the herd waited to be milked.

This was a landscape that wanted to be photographed, and I set immediately to work. Some moments later I heard a door slam and saw the small figure of a farmer emerge from the shadows at the back of the house. He peered up at me, wondering, no doubt, who this trespasser was. I was expecting him to yell, "Hey, what the hell do you think you're doing up there?" Instead, his words carried bell-clear through the early morning stillness:

HARVESTING PUMPKINS, VERMONT

In this picture Gladys Somers carries a couple of pumpkins down to the house for pie-making on a sweater-cool October afternoon. Gladys was not what you would call a feline enthusiast, although she welcomed cats in the barn. Her one complaint about my photographs of her was that I included too many cats.

A multitude of decisions are made as you take a seemingly straightforward photograph like this one. Should it be vertical or horizontal? (I took both.) Is the amount of sky important or should I include more road? Is placing the woman's shadow directly in the corner too pat? Will the tree to my right adequately shade my lens? If I get too close will the cat turn around or run? How many frames do I have left on this roll?

To some degree the mechanics of photography become automatic, but the aesthetic choices that go into making a picture should be anything but. Your mind should be churning while you photograph, but it should be looking to find the best possible image, not tumbling in confusion.

"When you're done, come down to the house and have some breakfast."

I soon discovered that the legendary reserve and suspicion of the Yankee hill farmer are a myth. I was always invited into farmhouses, asked to stay for meals, and given fat wedges of pie and countless cups of tea and coffee thick with golden Jersey cream fresh from the barn. I was allowed to tramp to my heart's content through fields and woodlots in search of photographs—usually with one of the farmer's dogs loping at my heels, eager for the company of another footloose soul with nothing better to do than explore the landscape.

The photographs in this concluding section are the result of these wanderings. They are only a few examples from an ongoing effort to capture the sense of this place. They were all taken within a mile or two of my home—simple pictures of rural life, of modest farmhouses and commodious barns, of pumpkins and jack-o'-lanterns, of the soft light of late May warming the backs of grazing sheep, of John and Gladys Somers giving thanks before starting their midday dinner.

These images also show that I found something to photograph that I felt strongly about, something I stayed with. Focusing your energy and vision on one particular place, rather than taking scattered images that bear no relationship to one another, leads to growth as a photographer. Choose a place in your own backyard or somewhere in the natural landscape that you care about, a place that you can easily reach for every change of light and in every season. Look for the true sense of it with your camera. Find, to paraphrase Gertrude Stein, the "there" that is there.

You will discover no shortcuts to becoming a better photographer. Go out and shoot, study what works and what fails, and go out and shoot again. It is the heartfelt response to what you see that leads you on, and the more of yourself that you put into your photography, the better it will be.

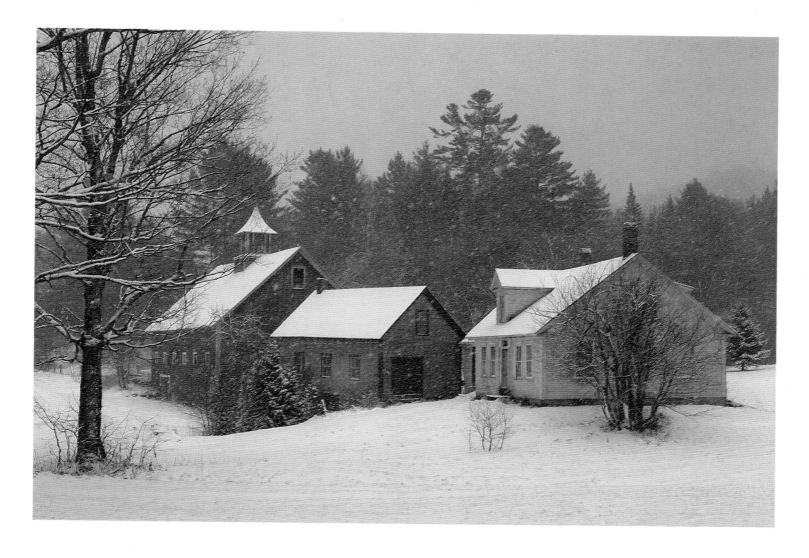

BEGINNING STORM, VERMONT

This farm lies in a tiny hamlet, no more than a crossroads, of northeastern Vermont. It bears the unfortunate name of Mosquitoville, though the insects are no more plentiful here than elsewhere.

I stood in an old cemetery on a slight rise fifty yards across the way and used a 105mm lens to emphasize the shifting roof planes and to make the buildings more immediate. A small human figure might have enlivened this scene, but no one came to the door when I knocked. Perhaps that's just as well—without a human figure, the picture gives a sense of the isolation and muffled quietness of being snowed in.

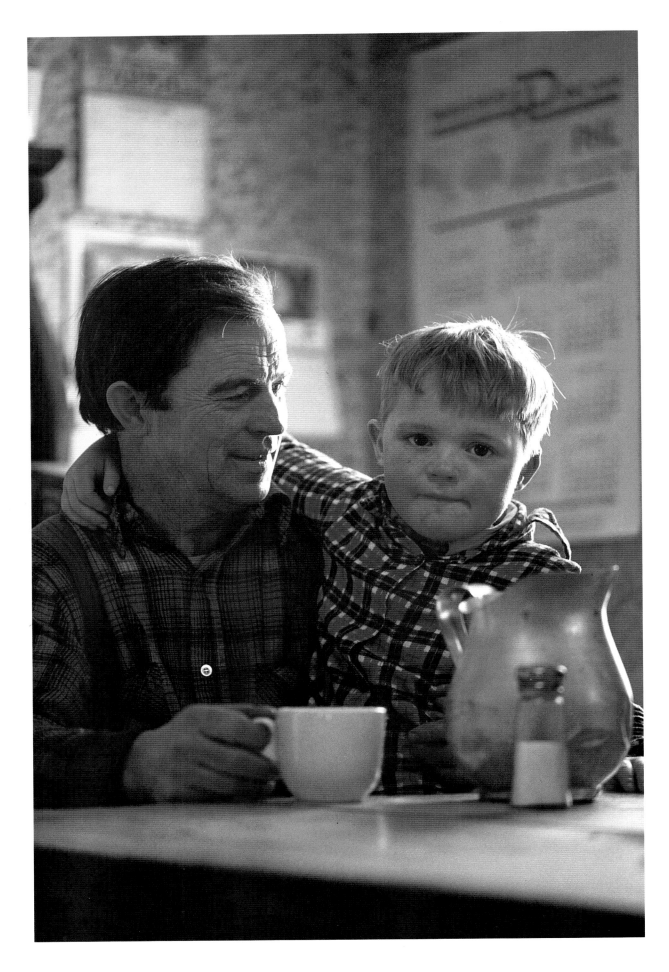

FRANK FOSTER AND NICK, VERMONT

Every afternoon at 3:00 P.M. sharp, Frank Foster, a local farmer and sawmill owner, shuts down his mill for a little while and walks to his house for coffee. Here, with some encouragement, the youngest of his eleven children looks tentatively at the camera. I used a 105mm lens, set my tripod at the boy's eye level about fifteen feet away, and waited for a moment that revealed a father's pride and a child's shy trust.

JACK-O'-LANTERNS, VERMONT

Some photographs are taken simply for the pleasure of the moment—a way of holding on to a smile. This photograph needed no tripod, no camera release, no long minutes of aesthetic struggle—it was just a quick sketch of three aging pumpkins expressing their displeasure at being left out in the cold. Photography is, after all, something to enjoy. A 105mm lens, hand-held, at 1/60th of a second.

PLOWED FIELD, VERMONT

By early May, the last thing anyone wants to see is more snow, unless you are a photographer and a brief storm has transformed a freshly plowed field into a choppy sea of whitecaps. I set my camera low to the ground, used a 55mm lens, and tucked the barn into the upper right-hand corner. Notice how the high, sloping horizon line and off-center placement of the building add tension to the image and contribute to the rolling, oceanlike feeling of the landscape. Subjects like this one that are easily broken into fundamental elements—the furrowed ground, the barn, the distant hill, and gray sky—provide excellent opportunities for experimenting with the effects of horizon placement, balance, and design in a photograph.

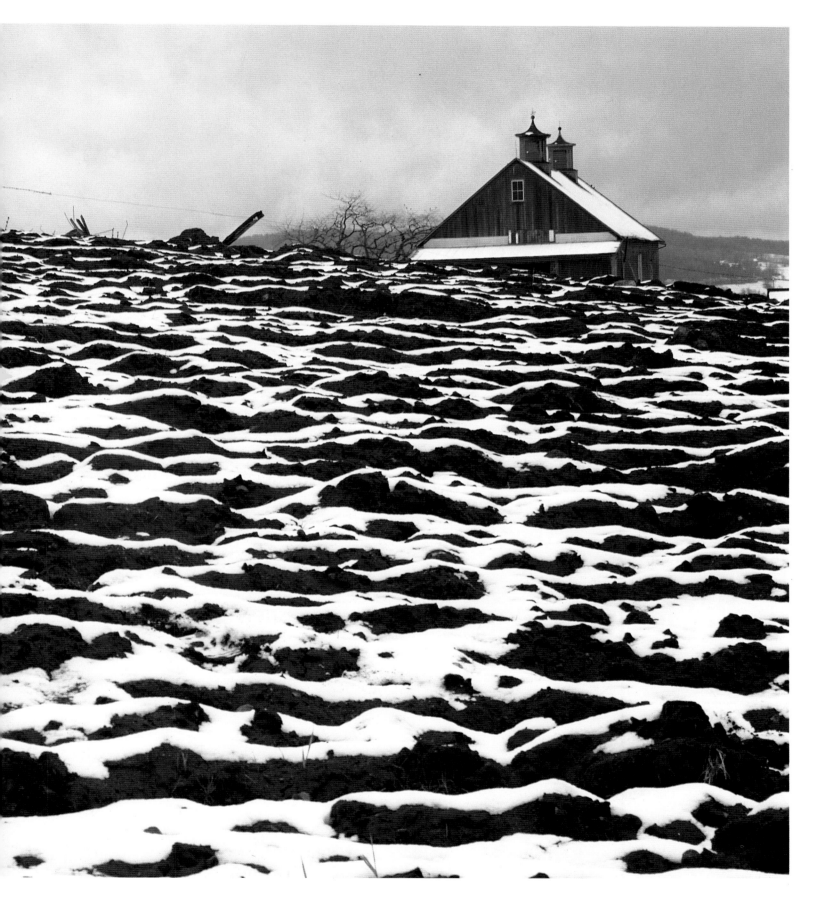

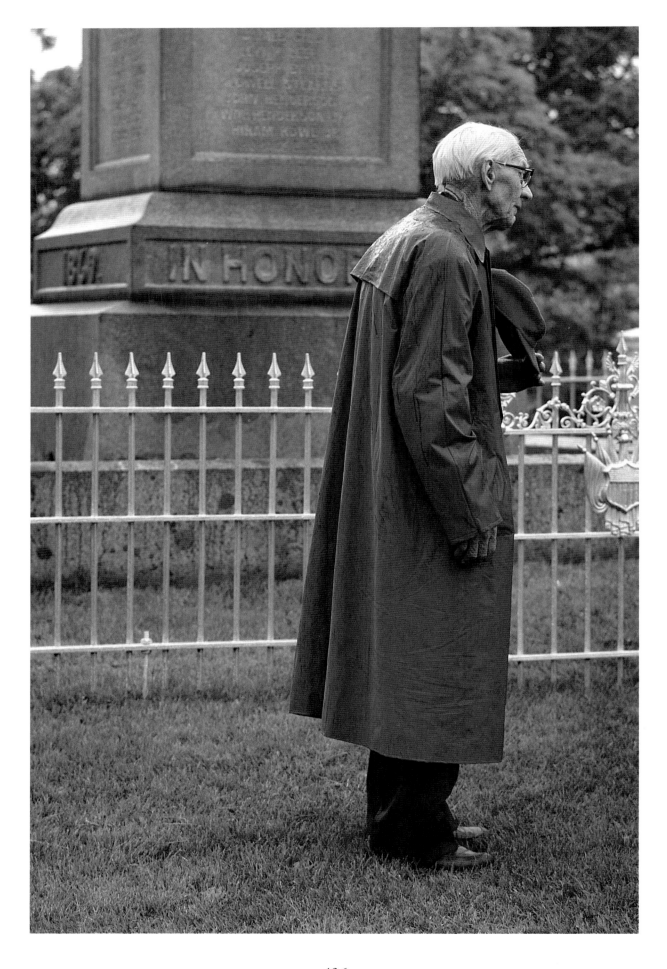

MEMORIAL DAY, VERMONT

Holding a red cap over his heart, an elderly farmer-patriot stands in the drizzle remembering a friend who died in war. Even small-town backwaters can't avoid the pain of history's greatest upheavals.

I moved to a spot where the gray of the monument would echo and balance the gray of the subject's rain-streaked coat, and I used a 200mm telephoto lens in order to remain at a respectful distance and still fill the frame.

VILLAGE WALK, VERMONT

There was something touchingly vulnerable about this small boy's shoulders, and the matched curve of the backs and the tilt of the heads clearly communicated that the two figures were mother and son. I followed them through the village with a 105mm lens until they reached an appropriate background; then I took the picture, leaving enough space in the frame for them to walk into. When you are hurrying to keep up with a subject like this and trying to anticipate the best instant, don't forget to concentrate on holding the camera perfectly still when you pause to shoot.

THE MORGAN PLACE, VERMONT

Only late May can make greens like this. The photograph of snow-covered furrows on pages 134-135 was taken only two weeks before this one. Spring in Vermont is an explosion of green.

What looks like a faint bit of rose-colored mist is actually dust stirred up by a passing car on the dirt road. I won't argue with the cause as long as the effect adds a touch of unusual warmth.

These sheep are pastured about a half-mile below my farm, and on hot summer evenings the clink of their bells rises up to my front porch, a welcome cooling sound like ice cubes in a glass.

Compare this photograph with the one on page 6: the same location, a different season, a slightly different vantage point, and a 200mm lens used here instead of a 105.

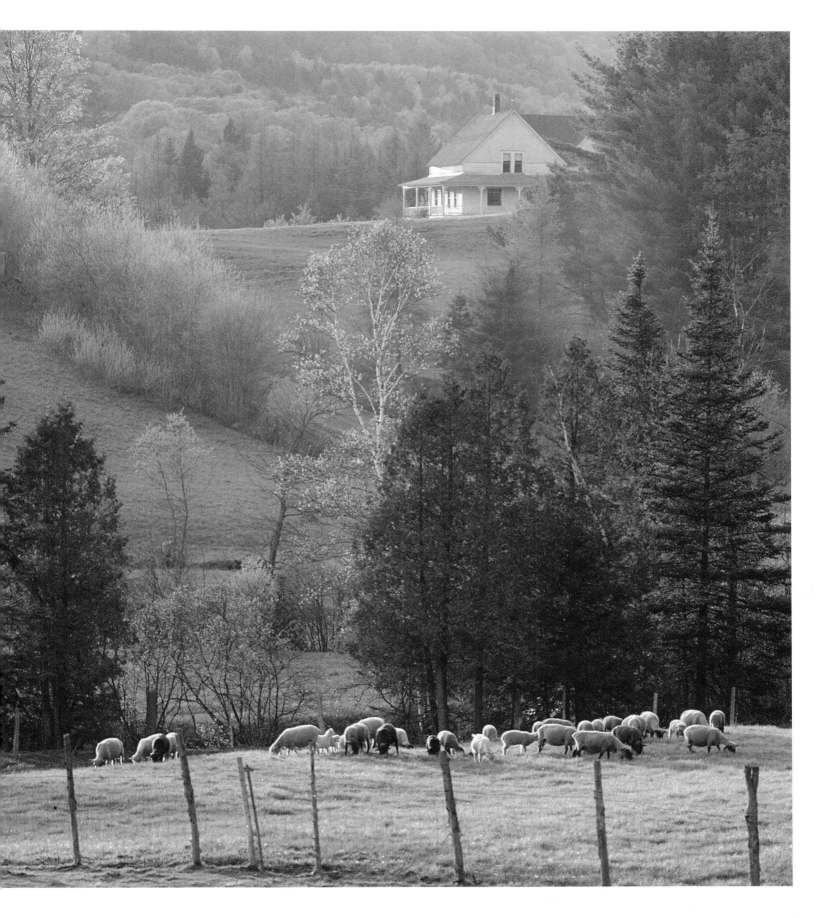

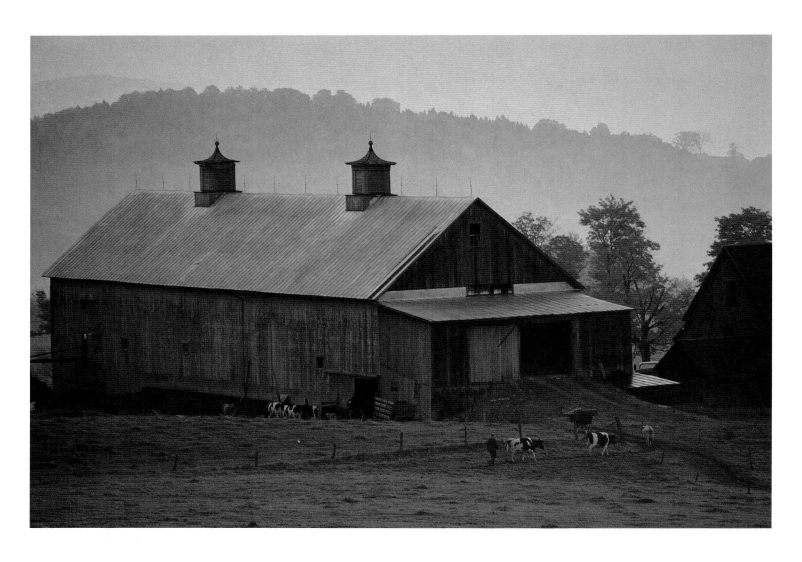

THE OLD MILLER PLACE, VERMONT

The farmers who raised these barns, at least a century ago, always described them as "commodious." Most were built entirely from lumber and granite cut and quarried on the place. This monster is the most commodious in my area, being five levels tall and 207 feet long—a cathedral for cows. I accompanied the farmer up to the night pasture to gather his herd for the morning milking, and stayed there, with 200mm telephoto lens mounted on tripod, to photograph his return to the barn. This was an ideal situation. I knew where he was headed and when he would get there and had plenty of time to frame the shot and anticipate the best moment.

JOHN AND GLADYS SOMERS, VERMONT

I'm a little mystified by this picture. I remember that John was saying grace, but we seem to be starting the meal with dessert. The place set closest to the camera was mine. I quietly got up, moved my chair to one side so it wouldn't block too much of the picture, and leaned against the kitchen door frame to steady the camera. Using a 55mm lens, wide open, I focused on the blue pitcher, which seemed a good compromise between the two figures. No doubt it was impolite to leave the table at this moment, but it was a question of risking rudeness or missing the shot. I've learned that if you're thoroughly engrossed in taking a photograph, people don't expect you to act normally, anyway.

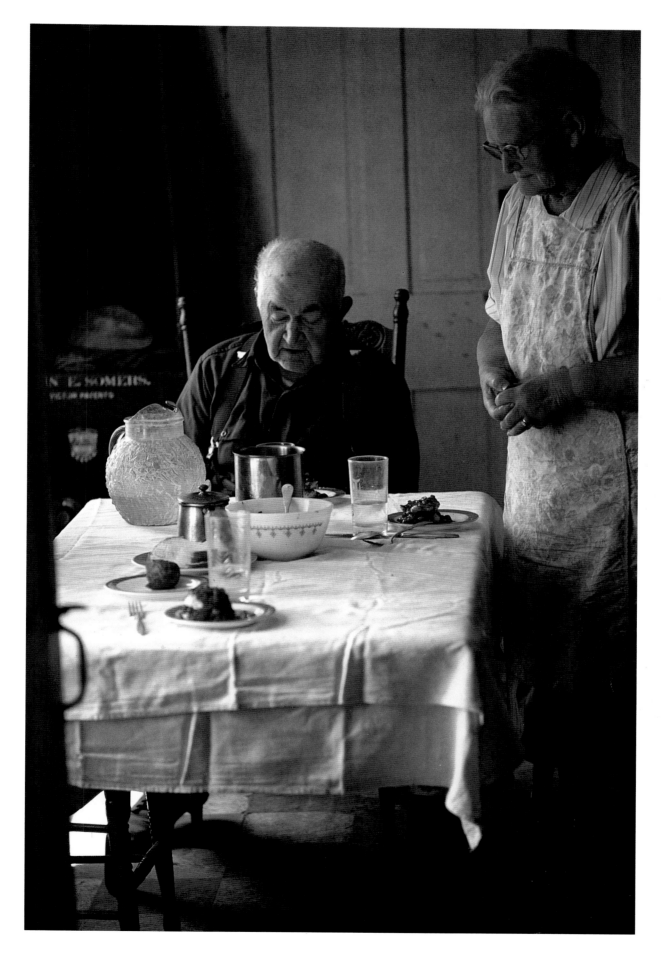

THE HOME PLACE, VERMONT

This is home, 250 acres of neglected fence, fields that need lime, piles of unspread manure, pasture that should have been clipped years ago, dead elms that need cutting up for firewood, and buildings in various degrees of disrepair—but from a distance it looks pretty good.

Having a place like this is like being married. The initial romance fades, and frustrations develop; you can't change the basic lay of the land any more than you can change basic traits of personality. But ideally you reach a deeper understanding and degree of affection. I'm still smitten.

More than anything else, this farm has given me pictures from the country: photographs of my children chasing geese through the mud—and being chased in return, of the sad old draft horse that came with the place, of deer stealing shrunken apples from the hard-frozen orchard, and of yellow maple leaves raining down in tight circles on the abandoned back road.

This photograph was taken from a hillside about a mile across the valley, with a 200mm lens, a polarizer to add a deeper blaze to the maples, a little surge of affection, and a curse at myself for not firing up the woodstove to provide the final flourish: smoke curling from the chimney—which needs cleaning.

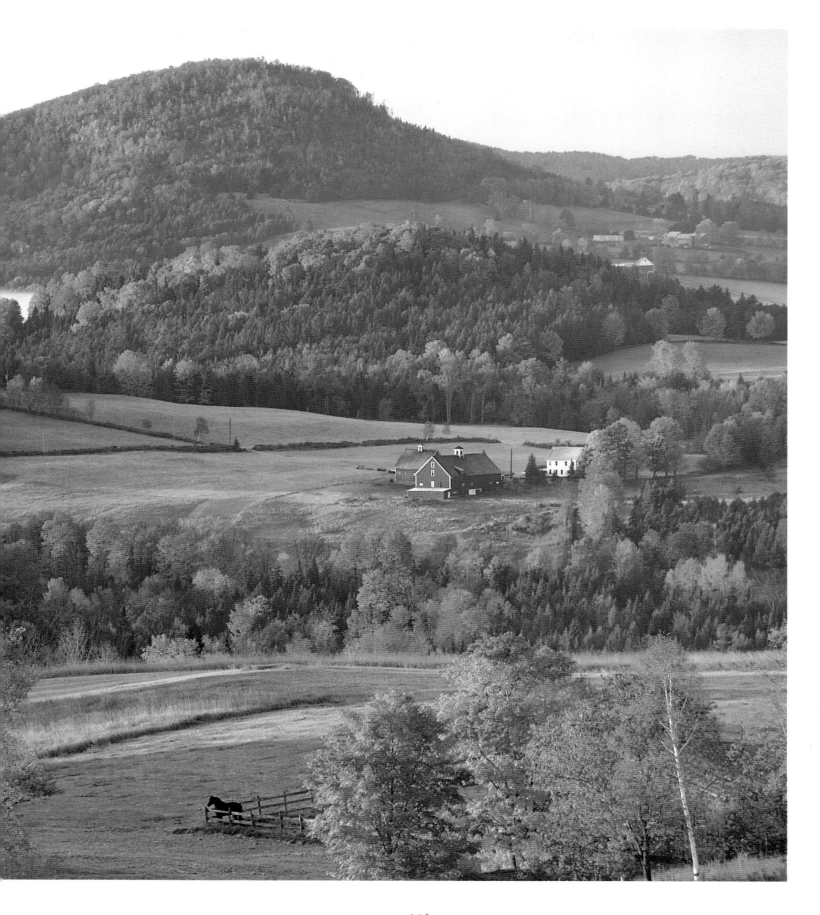

ACKNOWLEDGMENTS

I would like to thank the country people, near my home and in distant places, who have generously allowed me to photograph them, their homes, and the land they have cared for. This book also would not have been possible without the wisdom and assistance of my editor, Thomas H. Rawls. Thanks goes as well to James Lawrence, Sandy Taylor, and Castle Freeman for additional editorial guidance, and to Eugenie Delaney for her design skills and patience.

My appreciation extends to Rhoda Weyr, my agent, and to Dale Parker for working his usual magic in the lab. Finally, I am especially indebted to Mimi Edmunds for her encouragement and helpful insights, as well as her fortitude in photographing a camera-shy photographer.